RAINBOW MAGICK

TWELVE CREATIVE COLOR QUESTS FOR ART WITCHES

MOLLY ROBERTS

DAVID & CHARLES

www.davidandcharles.com

CONTENTS

WELCOME

You made it.

If you are reading these words, they were meant for you. If you have found your way to this book, you are undoubtedly a Rainbowmancer. A world bereft of playful wizardry lets loose a sigh of relief as you recover your gifts and bless us with your unique expression of rainbow magick.

Beyond The Candle and Over the Rainbow...

Like a roost of flustered attic bats, the discoveries fluttered in thick and fast, swirling in the mind and bursting through the windows of my eyes into the blazing sunset. Off on an adventure to see things as no other creature could.

Unbeknownst to me, the day I dedicated my life to art witchery was also the day I married into the world of rainbow magick. There would be no turning back from this generous dimension.

In my quest to learn more about the magickal uses of color, it became clear that many resources on the subject started and stopped with candle magick. Color was usually quarantined to a tidy little chart in the back of a book. While these

offerings were helpful, I knew there were more expansive, juicy, fun, and weird ways to experience color magick. The world of color was an exciting mythical bestiary too expansive and slippery to be contained by a feeble fence. So where were they hiding?

This little grimoire is the distillation of more than 10 years of researching, performing, and teaching color magick through exhibitions, classes, and play at the altar. *Rainbow Magick* is a creative approach to living in full color; a bubbling cauldron in which the scientific, spiritual, artistic, cultural, and soulful mingle and coalesce.

The following chapters are divided into Quests brimming with spells, crafts, and resources to help you experience the art of rainbow magick for yourself. We'll make space for creativity to flourish and invite your imagination to thrive.

A Rainbow Blessing

I send you a rosy wave of red silk
> to gently shake what has fallen asleep.

May a lucid dream of juicy tiger lilies float above to delight you,
> a beam of lemon-tart sunlight uplift you.

I send you a deep emerald pool to nourish your roots,
> and a sapphire stone who winks,
> so you can see your Beauty reflected back to you truly.

May an indigo voice show you the way
> and like a whale song, call you home low and slow.

I send you a violet sunset to tuck you in
> and remember all the Wild things you are
> and all the Wild things you have always been.

5

INTRODUCTION

WHAT IS COLOR?

What is the true nature of color? That depends entirely on who you ask: The physicist? The artist? The historian? The visionary? The witch? Color is a paradoxical creature of no-thing and many things at once.

The human eye perceives color when electromagnetic radiation tickles the cone cells of the eye. We assign these tickles into categories with names like red, yellow, and blue. Electromagnetic radiation is characterized by frequency and intensity. When that frequency dances within the visible spectrum we experience it as visible light.

Beyond the bubbly particles of the physicist's lab, color is also a system. This system is a code of interlacing meanings that vary wildly depending on your location in space and time. The white of purity in one country is the white of mourning in another. Four hundred years ago, pink was naughty, salacious, and closely tied to mainstream cultural concepts of masculinity, a distinctly different connotation to our current understanding of pink.

In the not-so-distant past, newspapers hurled venom at beastly artists who dared to dab one color next to another on canvas. The experimental Impressionist painters of the 19th century were condemned for their love affair with the dance of color and light. The new Impressionist aesthetic was rejected by the public as vulgar and offensive. The scandal!

When answering the riddle of what color is, we can peer into the emotional and psychic signatures of color. This is the realm of the magician who brings together correspondences, the mythic, poetic, and ancient story threads of colors, to weave magick in conversation with the universe. For the artist, color may morph from a tool to create the illusion of space, to a messenger who elicits an emotional response, changing once again into visual signals understood by a viewing public. Like the keys of a piano, facets of color can be tickled in innumerable combinations to create rich chords that speak to subtle layers of our being. Color is emotionally electrified.

Does color change? Or do we change? Perhaps we evolve together. Color is a riddle. Color is psychedelic optical opera, stories in constant motion, a collection of beings with fascinating histories, an ever-evolving language. Perhaps most importantly, color provides a dazzling set of sorcerous tools and field of experimentation for the Rainbowmancer.

*Color is a power which directly
influences the soul*

Kandinsky

WHAT IS RAINBOWMANCY?

Rainbowmancy is a word invented by your humble author to describe a holistic approach to living a charmed life with color. The Rainbowmancer uses color as the vehicle for enchantment, heightened perception, creativity, and transformation. Rainbow magick stirs together science, history, mysticism, practical magick, color theory, and the power of the imagination to cast a conscious spell on your world and make your life a work of art.

Rainbowmancy is a way of seeing, experiencing, and creating meaning. The rainbow magick journey is one of close observation, discovery, and invention. As a Rainbowmancer, you will learn to compile your own sacred color correspondences for art and magick, call on Color Guides for genius guidance, relish in sumptuous rainbow feasts to nourish the spirit, cast expressive glamours, divine prismatic transmissions from dreams, craft your own meaning-filled tools for growth and pleasure, and most importantly, *change the way you see the world forever.*

AWAKENING TO COLOR

I recall the day The Sight came to me.

The last breaths of summer were tumbling over the precipice into the melancholy beauty of autumn. Entering a still life painting class during my first semester of art school, I had already decided that I had no interest in painting fruit. Fruit was boring. Fruit would not satiate my deep dark artist soul. I had too many feelings to bother with fruit. In the sparse studio, we discussed shadow and light. My professor pointed out that shadows are not black, but in fact pools of color.

I snapped out of my fruit-hating trance. Shadows are a dance of color and light: navy, umber, forest green, and secret violet. Highlights and reflections weren't vapid blobs of white but fluctuate like reflective chameleons taking on the shifting character of their surroundings.

This revelation may not appear earth shattering, but it set something alight in my bones and jostled my neurons. This was so obvious. How had I missed it? What else had I failed to notice? This was the power of observation sinking in and sprouting as a miniature spiritual awakening.

I wandered around campus as an alien visiting this green-blue gem for the first time. Trees I'd passed countless times en route to the student union now shimmered with hidden blues and violets. Crimson leaves of Virginia creeper crawling up the brick walls vibrated cool and then warm in the traveling sunlight. Cocktail glasses dewy with condensation and pooling orbs of light kept me in thrall. It felt easy to open my heart to this world. This new way of seeing and experiencing was exciting and a constant source of curiosity.

OBSERVATION

The secret key to awakening your Rainbowmancer Sight isn't a secret it all. The key is noticing what is around you. Pay attention. Offer the world your curiosity. Show interest in your surroundings by building your powers of observation and noticing the ways colors are at play in your world.

How do hues flicker when cheek to cheek? What flavor is the shaft of light pouring through the window, suspending dust motes in slow motion? When is the moment that dusk bleeds into night? What color are your eyes really? What seasonal bouquet is being offered up by the natural world? Expand the scope of your observations to include colors, shadows, textures, and patterns. Like a biologist hidden in the thick of the rainforest studying a rare species of gleaming beetles, treasure your observations; catalogue, scrutinize, appreciate, and take note of the smallest details.

RECLAIMING WONDER

You may be skeptical about this moon-eyed observation thinking, "where I live isn't interesting" or "my neighborhood is boring". Fear not. We can overcome the obstacles of boredom rot and inspiration constipation with a magickal axiom:

The World is fascinating.

Invite fresh perspective and ignite a plume of wonder in the core of your imagination with the incantation, *"The World is fascinating"*. Practice by picking up an object in your home and really see it. What we think we see and what we actually see can be very different. Visit a place you've been hundreds of times and drink in the details. What do you see? What questions arise in your mind? Who made it? How does the light change throughout the afternoon or through the astronomical dance of a season? Who else has observed this place or touched it with the presence of their senses? Who else might be here with you now? *The World is fascinating.*

RAINBOW SIGHT PROMPTS

Pretend you are a newborn child experiencing an object or place for the very first time with your squeaky-fresh infant perspective. What do you see? What do your senses tell you?

Imagine you can drink color with your eyes. How does this trippy play heighten your awareness?

Allow your vision to relax and blur, melting definition to clearly read the color story of your surroundings.

Gaze at images, items, or locations upside down to gain new appreciation and insight.

Look at images, objects, or locations as reflected in a mirror. What is revealed?

View a place or object from the angle of a creature. How might a bee or fly perceive it? A fox, bat, snake, or giant squid?

Do nothing. Sometimes slowing down and allowing for spaciousness is all it takes to open insight.

Create a Wonder Oculus (see next page) to explore and reframe your Rainbow Sight adventures.

WONDER OCULUS

Create a portal through which you can experience the world anew. The Wonder Oculus is a magickal tool that reveals beauty with stunning clarity. Novelty, inspiration, and wonder await.

The scrappy Rainbowmancer can assemble a Wonder Oculus from any supplies that are available and suit their adventure style:

+ A bamboo skewer and hoop earring glued together for a Wonder Oculus wand.

+ A monocle crafted from a sunglass lens and a toy ring.

+ An ornate miniature frame on a chain of gold or silver links.

The frame of the Wonder Oculus delineates scenes into micro works of art. Bring your Wonder Oculus out into the field: the living room, the closest park, a coppice of trees, supermarket, or rooftop. Peer through your Wonder Oculus to reveal vignettes of unnoticed wonders. There is an element of slowness inherent in rainbow magick. In a world of distraction, a distilled moment of concentration is a gift that steadies and romances us. If you perform no other act of Rainbowmancy, this humble act of noticing will surely change your perception and feed the poetry of your days.

AT THE HEART OF RAINBOW MAGICK

Play is the heart of rainbow magick. Dust off your instinctual abilities to "make believe" and reveal a tangible world as rich as any fantasy. Play offers a cure for wonder atrophy. Play pulls away the milky veil that dampens our curiosity to reveal the glimmer of our genius. This is an important magickal skill that can be developed only through very serious play. The list below gives you some hints and tip on how to begin your play.

THE PLAY PRIMER

+ Remove distractions.

+ Relax.

+ Let go of expectations.

+ Be curious. *The World is fascinating.*

+ Do what amuses you.

+ Give yourself permission to feel good and enjoy yourself.

+ See what happens...

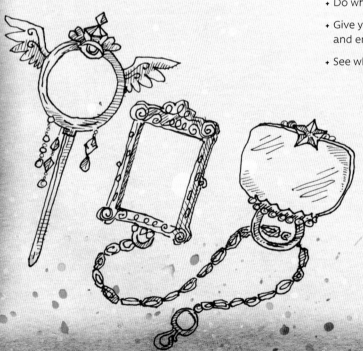

WHY WORK WITH COLOR?

The rainbow has long been the ally of artists, healers, magicians, and sages. Working with color can be simple and woven into the context of our daily lives. Color is an abundant renewable resource given freely to anyone who wants to play.

Living as a Rainbowmancer and cocreating with color deepens our perceptions. Deep observation leads to deep contemplation. Deep contemplation leads to unexpected magick and an unusually deep life.

Magic exists. Who can doubt it, when there are rainbows and wildflowers, the music of the wind and the silence of the stars? Anyone who has loved has been touched by magic. It is such a simple and such an extraordinary part of the lives we live

Nora Roberts

MEET THE RAINBOW

It is time to walk through the auroral halls of the rainbow and meet the spirits of color. The following is an introduction to the dazzling inhabitants of these halls. Each color ray has its own multifaceted essence and area of magickal expertize. While these introductions attempt to encapsulate as much helpful information as possible, your cultural understandings and personal experience will always offer potent insight.

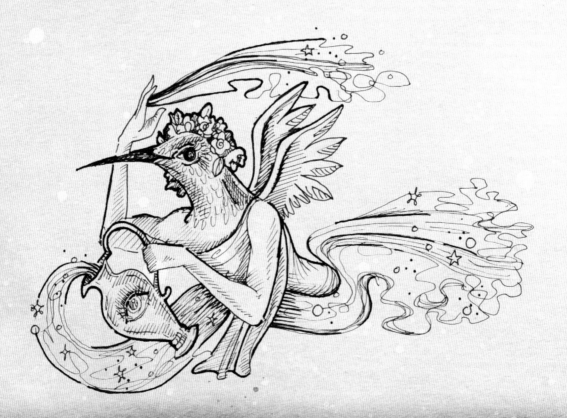

Red

Red bursts with passion, vitality, and daring tendencies. Associated with the planet Mars, red is sensuous, athletic, competitive, and sometimes violent. The legendary ruby red prize of the alchemists, the Philosopher's Stone, was said to cure all diseases and grant immortality. Red gushes life force, ambition, success, strength, anger, destruction, and explosive emotions. As the color of blood, it has strong associations with birth and the tomb. Advertisements and commercial spaces use red to ramp up appetites for consumption and illicit quick decision making. The softer side of red speaks to rivers of memory, deepening relationships, and connectivity.

The power of red can be called upon for magick to invigorate, attract attention, stir passion, return home to the body, protect, motivate, cultivate strong instincts, build confidence, connect with ancestors, invoke the inner warrior, and draw on reserves of strength. Red stirs, shakes, and lends velocity. Work with red to bring heat and momentum to your aims.

Orange

Orange is the life and soul of the party. Zesty, happy, assertive, and buzzing with creativity, orange effuses conviviality, joy, and a sense of meaningful connection wherever it appears. This fiery, outgoing color is linked to both our Sun and planet Mercury, promoting social ease, spontaneity, playful sensuality, enthusiasm, and alertness.

Associated with the autumn season and harvest, orange speaks to a stable sense of abundance, wealth, and prosperity with strong foundations. As the messenger of both dawn and dusk, orange emits a sense of renewal and optimism. Orange can be helpful in workings for strengthening life force, embarking on new adventures, encouraging healthy appetites, improving memory, mental flexibility, word craft, public speaking, inviting creative inspiration, and building a neighborly community. All variations of orange offer warmth, stimulation, and hospitality. Play with orange to lend confidence, freshness, and humor to your spells.

Yellow

Yellow emanates energizing solar qualities like intellect, focus, clarity, and hopeful anticipation. In its softer effervescent forms, yellow conjures joy, levity, illumination, and beams of fresh thought. In its more intense incarnations, yellow warns of aggression, poison, danger, and trickery. As an attention grabbing, highly visible, and sometimes shocking color, advertisements capitalize on yellow to draw attention and sharply direct the eye of the viewer. Appearing as dandelion blooms, bee-jeweled honeycomb, and the quick lightness of songbirds, yellow speaks to persistence and richness of the spirit.

Call on yellow to generate new ideas, bring attention to issues, aid study, increase feelings of self-worth, build healthy boundaries, promote physical health, kindle friendships, and ignite enthusiasm for life. The phosphorescent quality of yellow embodies an upward movement, expansion, and transcendence. When directed gracefully, yellow has the power of persuasion.

Green

Summoning the scent of petrichor and spongey banks of moss in mountain glades, green promotes rejuvenation, nourishment, peace, and tranquility. Oxygenating, nurturing, soothing, and balancing, green is associated with growth, renewal, and the terrain of the heart. Affiliated with the planet Venus, green is an excellent ally for artists, designers, and beauty seekers of all kinds looking to expand their capacity for creating beauty and new aesthetic experiences. Pastel greens are generous, calming, and compassionate while bright greens are vital, energizing, and activating. Dark greens root us and assist with grounding, mindfulness, security, and deep rest. While red is associated with the lusty dimensions of love, green denotes deep affection and intimacy.

Partner with green for spells concerning luxury, beauty, fertility, growth, holistic healing, recovery from injury or emotional ordeal, easing grief, ecological work, restorative justice, regenerative magick, financial literacy and wellness, reclaiming wildness, and developing a rapport with nature spirits. The earthy aspect of green quenches, anchors, and consoles.

Blue

Celestial, atmospheric, and oceanic, blue is the cool unifying patron of planet Earth. Light blues evoke oneness and airy freedom. The depths of dark blues convey authority. In league with Jupiter and lightning, blue crackles with wisdom, idealism, opportunities, and the wild unknown. In its watery elemental form, blue is sensitive and tuned into the fluctuating swells of emotions and dreams. Blue may also present as mournful, melancholic, and the expanse of the subconscious. The famed Italian renaissance astrologer, Marsilio Ficino recommended followers paint ceilings blue with images of the cosmos to promote heavenly thinking and a balanced body.

Call on blue for opening communication, stabilizing conditions, legal matters, business endeavors, promoting peace, and inviting divine inspiration. Blue can be particularly powerful when applied to humanitarian efforts and liberation from oppressive cultural expectations. Blue is a helpful partner for gently dissolving blockages, offering devotions, and deepening meditation. Use blue to soften, comfort, and bring spaciousness to a situation.

Indigo

Moody, surreal, and psychic, indigo strengthens intuition, dreamscape travel, and spiritual connection. Indigo corresponds to the numinous seas of Neptune, the higher mind, sincerity, abstract ideas, and the disintegration of illusions. Indigo makes us keenly aware of the web of life and encourages truth telling, integrity, authentic expression, and service to others.

Psychologically, indigo acts as a sedative to reduce stress and promote rest. In interior design, indigo touts drama, theatrics, and opulence. As the flash of a dashing peacock and glistening wings of the morpho butterfly, indigo lends an air of the spontaneous, mysterious, and ethereal.

Call on indigo for accessing hidden wells of wisdom, developing intuition, expanding perception, digital detoxing, finding purpose, unlocking spiritual gifts, creating fantasy worlds, and calling in far-out dreams. Work with the powers of indigo for enchantments involving artistic pursuits, overcoming addictions, and living in alignment with ideals. Indigo energy has a saturating, immersive, trance-like intensity.

Violet

Violet is a shifty wizard with many faces. One moment, violet is an eccentric, whimsical inventor and, in a wink, a stern, mysterious hermit. Violet whispers to the ancient, cryptic, and mystical. Associated with Jupiter, Mercury, and Saturn, violet speaks to sovereignty and occult knowledge. Rich, vivid violet reflects the spiritual, authoritative, and sacred. Pale versions of purple like lavender and periwinkle soften stress, relieve mental tension, and promote serenity.

In its bolder variations, violet can vibrate with audacity, fearlessness, fanciful ideas, and charisma, making it a strong ally for performers, protesters, and creative geniuses of all stripes. In true shapeshifter form, the flower that bears its name communicates humility, shyness, and modesty. Colors are paradoxical creatures after all.

Call on violet for lucid dreaming, assistance with astral travel, developing strong character, leadership, dancing to the beat of your own drum, taking up space, blazing trails, visioning, and glamour magick. Violet has a diaphanous, flexible, and dynamic quality as it mediates between the material and the etheric.

Brown

Brown articulates practicality, manifestation, and security. Rugged, no-nonsense brown evokes the ample velvety qualities of drinking chocolate, supple armchairs, and musty library stacks. Stabilizing, grounding, and nourishing, brown symbolizes strong earthy qualities of comfort, safety, support, fertility, survival, generosity, and sanctuary. Summoning the depths of the soil, bracken, and the mycelium network, brown connects us to the essential cycles of decay and creation.

This mutable neutral mixes and pairs easily with other colors offering depth and structure. Browns can suggest sweetness, trust, and an approachable informality. Use brown to build the foundation for long term projects, kitchen witchery, home-keeping arts, wealth magick, protection, grounding, cultivating discernment, eco magick, creature communication, land and animal care. Brown, tan, sepia, and umber are all effective counter spells for over complication, over consumption, or over stimulation. The color brown embodies density, heft, and substance.

White

White is the purifying horn of the unicorn, the transcendental cloud palace, and the infinite expanse of the blank canvas. In the western hemisphere, white is most often associated with purity, newness, beginnings, innocence, and new levels of understanding. Its association with the moon gives white an air of transformation, renewal, and sensitivity.

Institutional white denotes hierarchy, cleanliness, precision, and austerity. An abundance of white can create a calming ambience of minimal elegance and simplicity. It also has potential to wash away into blandness and boring monotony. As a messenger of mourning, white may also sing a spectral song of wandering spirits, the beloved dead, and supernatural stirrings.

Though white appears to be nothing, white is the combination of all visible waves of light so it contains all the colors of the rainbow. When in doubt or in a pinch, white will work! Call on the spaciousness of white for healing, cleansing, memorializing, honoring grief, shielding unwanted influences, illumination, simplifying one's life, restoring a sense of wonder, and new adventures.

Grey

Grey is an experienced teacher who knows the magick of moderation. While often characterized as an unglamorous color, grey peppers in essential wisdom, experience, and nuance. Like the sage's beard, silken spiderweb, and roosting Mourning dove, the cocoon of grey is soft, composed, and subdued. Grey is often mistakenly underestimated. Though a wise, judicious guide, grey may also obscure, hide, keep secrets, pose frustrating riddles, or just pretend to be boring.

While grey denotes composure, it can don a more ominous and tempestuous cloak of rough waters, rolling thunder clouds, and volcanic heaving. Much like brown, the neutral qualities of grey make it a supportive partner in adding depth, nuance, maturity, and structure to your efforts.

Use grey to invoke your inner elder, deepen study, aid divination, neutralize chaotic situations, quiet the overactive mind, quell compulsive behaviors, cultivate patience, equanimity, and sobriety. Grey also works for invisibility, skill building, long-term goals, and uncovering wisdom in plain sight.

Black

The vast abyss of Nothing and the fecund richness of Everything, black is a beginning and an end. Associated with Saturn, black is entwined with the occult arts, the passage of time, independence, authority, severity, limitations, boundaries, maturity, and sophistication. Black covers an impressive array of natural and psychological scenery: the cool cave mouth, a moonless midnight sky, the underworld of the seed, dark nights of the soul, and the mystery of the grave. Black is a sphinx, paradoxically a force of both detached domination and a most tender mother.

Much like its counterpart white, black may feel both expansive and oppressive simultaneously. A prevalence of black in an interior space can feel luxurious and formal or depressing and overbearing. Commercial brands often use black to project an air of exclusivity, confidence, and authority.

Call on black for overcoming obstacles, defeating procrastination, honoring endings, emotional closure, metamorphosis, setting boundaries, shadow work, dissolving unhelpful patterns, exuding authority, hex breaking, and heavy-duty protection. Bring black to situations that require fearless and resolute clarity.

Pink

Pink is a bestie who knows how to have fun and takes nothing too seriously. Supple, abundant, and ripe, pink has become associated with Venus, friendship, romance, pleasure, the material world, youthful energy, nostalgia, and whimsy. Pastel pinks speak to the renewal of spring, innocence, and compassion, while juicy fuchsia and hot pink flirt, entice, and exude a perfume of unbothered irreverent sensuality. Pink is a popular decorating choice for healthcare settings as softer shades calm the nervous system, negate stress, and soothe tension.

As a polarizing color, drawing both admiration and ire, pink can be used skillfully to call for attention, playfully poke at social norms, and encourage debate. Call on pink to invite beauty, friendship, affection, romance, positive body image, consistent self-care, love of life, inner child healing, cheeky superficiality, recovery from emotional strain, and entertaining serendipity.

Gold

Defended by fire-breathing dragons and adored by ambrosia nibbling gods, gold denotes the sacred, noble, affluent, and powerful. Alchemically, gold represents human perfection and the prize of our highest potential. Gold is a gifted healer, historically prescribed as medicine to fortify the spirit and body. Gold's relationship with the sun awards it the powers of leadership, optimism, inner strength, revitalization, radiance, and immortality. Gold invites the viewer to look towards the sacred, to be struck with awe and ecstasy, and aspire to greatness. But beware of gold's shadow baggage of dogma and excess.

Gold has numerous iterations: as a metal, a finish, hue, tone, and shade. The glinting powers of metallic gold attract attention and project energy. More subdued versions of gold may act as a neutral, providing a quiet, understated strength to the mix.

Bring gold into the fold for rainbow magick concerning vitality, stamina, personal sovereignty, cultivating gratitude, responsibly attracting material resources, building wealth, success, good luck, robust self-esteem, projecting good will, and maintaining strong ethics. Bring gold to situations where you need to shine.

Silver

Silver alludes to the graceful, angelic, and changeable. Associated with the moon, silver appeals to the interior world, cyclic mysteries, and shape shifting. Worn, tarnished silver harkens to durability, eloquence, and antiquity. Steely, gleaming silver evokes modernity, utility, and industrial efficiency.

As a metal, silver is quite soft and workable, which gives it a mutable, mercurial, and elusive character. Shimmering silver suggests the otherworldly: the clingy cobweb gown of Queen Mab, the sheen of a scrying mirror, or a legendary lost sword emerging from a glassy lake at dawn. Modern references offer the gleam of fog-shrouded disco balls and intergalactic travel of science fiction and futurism. Silver is the patron of Fabulous Weirdos.

Incorporate silver into interiors, glamours, and art magick objects for reflective return-to-sender magick. Silver is a fine color for spells concerning harmony in the home, smooth communications, easing negotiations, increasing flexibility, acceptance, life transitions, grace, gambling, travel, psychic development, evading malefic influences, and romancing the mundane. Silver is an indispensable ally for glamour creation.

WHAT IS COLOR THEORY?

Now that you have been properly introduced to the inhabitants of the auroral halls, we venture into the realm of color theory. We'll explore the dimensions of the color wheel, the virtue of colors, and the wild world of color schemes and how they intertwine to weave magick.

Color theory is a compilation of established rules that help us understand color relationships and communicate with other people about color. These guidelines give us a map to navigate the seemingly endless terrain of color. Don't be intimidated, Rainbowmancer. Even the tiniest crumb of color theory will have a massive impact on your abilities to recognize color at work in the world, develop your own visual language, and choose color allies for creative and magickal arts. We'll dabble at the edges of color theory, with just enough information to provide the structure for future cloud castles. Let's equip you with the language of the Rainbowmancer.

The Color Wheel

Also known as the color circle, the color wheel was introduced by your favorite alchemist, Isaac Newton. Published in 1704, *Optiks* presented an early version of the wheel. Over the centuries, the wheel has grown as our understanding of the color spectrum evolved. Developments in software wizardry continue to provide ever more granular opportunities to explore the mushrooming constellations of color. The humble color wheel illustrates the expanding universe of color in a convenient diagram.

If the color spectrum is always expanding, this means color theory is a living art that twists and spirals through time. We have access to hues our ancestors never saw. Imagine being the first human to see peacock blue or neon green? And color discovery is not relegated to an ancient past! As recently as 2009, Mas Subramanian, a chemist working at Oregon State University uncovered a new color by accident. This otherworldly shade of blue, YInMn (or Mas Blue), is a striking reminder that there are still mysteries waiting to be revealed. How many more spirits of color will make themselves known in the future?

The color wheel provides artists, designers, and Rainbowmancers with an agreed framework to communicate about color and gives structure for color schemes.

Primordial Colors

The *primary colors* of red, yellow, and blue are the root of all other colors.

When primary colors are mixed, *secondary colors* appear. Red and yellow create orange, red and blue give way to purple, yellow and blue produce green.

Tertiary colors are where things get interesting. Tertiary colors are achieved by mixing a primary color with a near-neighbor on the color wheel. This mixture gives way to endless variations of red-orange and yellowy-green, bluish purple and red-violets. These colors populate the nooks and crannies between all the primary and secondary colors. We could be bold and say tertiary colors are code for "every color you can feasibly create".

The Virtues of Color

Imagine hue, value, and saturation as the virtues of color. Deepening our understanding of these qualities gives us ever more subtle knowledge and language to describe what we see.

Hue is the pure essence of a color. A hue is typically the name we give a color. Red is a hue. Aquamarine is a hue.

Value refers to the lightness or darkness of a hue. We can imagine value as a scale that moves from light to dark. White is at one end of the value scale, being the lightest and black is at the other end, being the darkest. When folks refer to shading, the quality they're speaking of is value.

Saturation denotes the purity and intensity of a hue. High saturation colors tend to be bright, vivid, or even fluorescent. Low saturation colors tend to be soft, subtle, and muted.

Colors can be warm or cool in temperament. Red, yellow, and orange are warm colors. Green, blue and purple are cool colors. These warm and cool colors sit opposite each other on the color wheel.

TINTS. TONES. AND SHADES

This helpful trio of descriptors allows us to identify colors in even more detail.

A *tint* is a hue with the addition of white.

A *tone* is a hue with the addition of grey.

A *shade* is a hue with the addition of black.

The nuances of tints, tones, and shades allow us to see and create a wider range of color scheme possibilities.

Color Schemes

A color scheme is an organized posse of colors drawn from their placement on the color wheel. Color schemes allow us to bring mood, depth, and style to our work. We create schemes by making intentional selections that follow a pattern. If hues are the guest list, the scheme is the party. We'll discuss more about creating schemes and palettes for aesthetic development in the Rainbow Glamour Quest.

Complementary Color Schemes: Complementary colors appear directly across from one another on the color wheel. Examples of complementary colors are red and green, blue and orange, yellow and violet. Complementary colors support one another with vibrant, attention-grabbing magnetism.

Monochromatic Color Schemes: Monochromatic schemes are made up of variations of the same color. For example, a red monochromatic scheme will incorporate shades, tones, and tints of the same red hue ranging from brick burgundy to cherry red to a petal pink. Any color can be used to create a monochromatic scheme. These schemes lend an air of elegance, focus, and organization.

Analogous Color Schemes: Analogous colors are hues that sit directly next to one another on the wheel. Examples of analogous color schemes would be red, orange, and yellow, or yellow, green, blue, or blue, violet, and red. Their cozy proximity on the wheel means analogous schemes offer a harmonious feel without ever being dull.

Triadic Color Schemes: These are colors which appear equidistant from one another on the wheel. Imagine an equilateral triangle hovering over the color wheel; triadic colors are where the points touch. This triangulation could appear as red, yellow, and blue or orange, green, and purple. Triadic color schemes gain sophistication and style when secondary colors are used. These arrangements tend to be high energy and very dynamic.

Reading the Rainbow Code

Why bother with the technical theory bits in a magick book? The answer is the more language we have available to us, the deeper we understand what we see. Color theory is the Rosetta Stone that cracks rainbow code, allowing us to translate the hieroglyphs of color and reveal their secrets. These natural laws of color are usually answers to mysterious questions like why do I love this? Why does this work? Why is this harmonious? What is the story here? What is being said without being said? Now this knowledge is in your hands.

Fortified with this information, you will naturally notice color qualities and schemes flirting with the edges of your vision everywhere you look. Take your time with practicing color theory and watch your rainbow magick abilities become second nature. Whether mixing paint on a palette, assembling an altar, or designing a glamour, color theory supports our creative efforts and ensures our rainbow alchemy results in a pleasing effect.

Tools of the Rainbowmancer

You need supplies before embarking upon a quest and your rainbow magick adventures will require a few tools. Magickal paraphernalia is customizable and personal to the Rainbowmancer. The drawing here shows a number of possible allies to accompany your journey. What items would you add to this list?

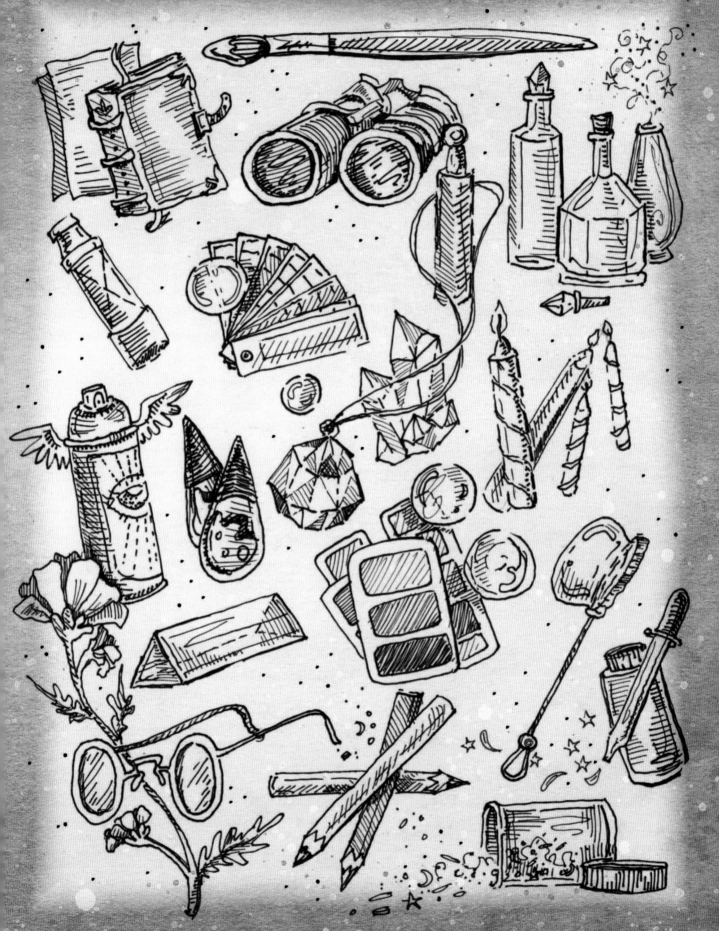

The Quests

CREATE A COLOR CACHE

A color cache is a receptacle for magickal experimentation, color inspiration, documentation, and any ephemera relevant to your rainbow magick adventures. In this quest, we'll discover a variety of forms your color cache may take and what to feed your book to ripen your Rainbowmancy.

OPEN AND REVEAL

In rainbow magick, a cache is anything that opens and reveals... something. This cache may take the form of a book (which magicians know is much more than paper between two covers) or a container. Your cache is your color treasure chest and should assume whichever form feels just right to you.

In your quests, you may find the spirits of color would like to reside in a folio, an augmented rolodex, or a towering stack of altered playing cards bound with a satin ribbon. Perhaps your cache takes the shape of a meticulously kept binder, spiral-bound notebook, or cookie tin stuffed with ephemera. A banged-up vintage toiletry caddy would make a fine home for your color discoveries, as would a cigar box tucked full of chipboard coasters. Your color cache may be that lovely hardcover journal winking at you from the shop window, a floppy sketchbook, or a fistful of envelopes sewn together as a catalogue of hungry pockets. Maybe your cache takes the form of a long, crinkly, ever-growing scroll of your color magick saga. Maybe it's a folder on your desktop.

Choose a form for your color cache that feels exciting and workable for you. Give it a name that tickles you. Or perhaps, your cache will have thoughts about its own name.

What to Feed Your Color Cache

Once you've decided on a form and gifted your cache a name, it's time to feed it! Your color cache is a treasury of inspiration, references, and insights. Below are a few ideas about what to include in your own color cache.

As you fill your color cache, you will see your own visual language unfurl before you. This is a space for ideas and impulses to ferment, sweeten, develop body, and become fully formed inspirations. Your color grimoire will grow and evolve as you do. Be generous and enjoy adding to this resource. Feed it well. Feed it often. And it will feed your magick.

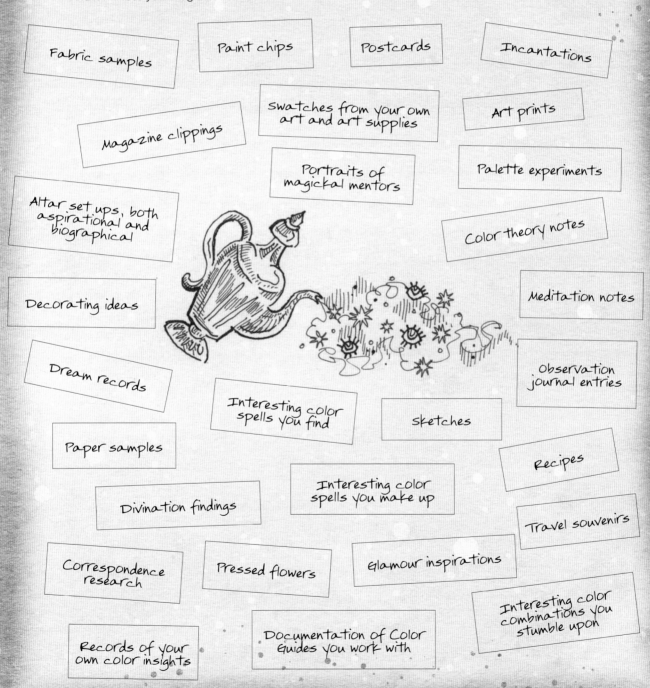

Fabric samples

Paint chips

Postcards

Incantations

Magazine clippings

Swatches from your own art and art supplies

Art prints

Portraits of magickal mentors

Palette experiments

Altar set ups, both aspirational and biographical

Color theory notes

Decorating ideas

Meditation notes

Dream records

Observation journal entries

Interesting color spells you find

sketches

Paper samples

Recipes

Interesting color spells you make up

Divination findings

Travel souvenirs

Correspondence research

Pressed flowers

Glamour inspirations

Interesting color combinations you stumble upon

Records of your own color insights

Documentation of Color Guides you work with

Rainbow Scratchboard Ring Grimoire

Let's create an adaptable upcycled grimoire with a rainbow scratchboard cover and generous, adjustable pages ready to accept your enchanted color stash.

YOU WILL NEED

+ Cardboard box
+ Craft knife
+ Masking tape
+ White acrylic paint
+ Oil pastels
+ Liquid dish soap (washing-up liquid)
+ Black acrylic paint
+ Large paint brush
+ Scratch tool or wooden skewer
+ Scrapbook paper
+ Glue
+ Hole punch
+ Clear sealant or water-based glue-sealant
+ Large binder rings
+ Page protectors

1. Cut the cardboard box down to two pieces roughly 9in x 12in (23cm x 30cm). These pieces will be the front and back covers of the grimoire. Cover the edges with masking tape if you'd like to disguise the cardboard.

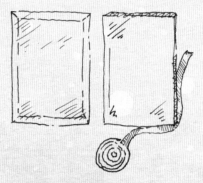

2. Prime the cardboard with a thin layer of white acrylic paint and allow to dry.

3. Using oil pastels, color the entire surface of the painted cardboard, blending the pastel into the surface.

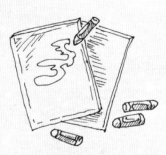

4. Mix a small dollop of liquid dish soap into the black acrylic paint. Using a large brush, coat the colored cardboard with the soap and paint mixture. Allow the black paint to dry until it loses its stickiness. Note the soap will prevent the paint from becoming bone dry.

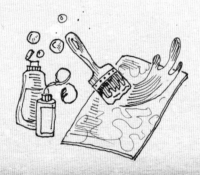

5. Using a scratch tool or wooden skewer, scratch symbols, drawings, or words of power into the black paint to reveal the rainbow colors underneath.

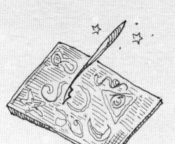

6. Cut two sheets of decorative scrapbook paper (or your own artwork) approximately 8in x 11in (20cm x 28cm) and glue them onto the inside covers.

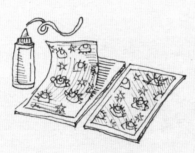

7. Using a hole punch, punch three holes into the top, middle, and center of both covers. Use the holes in the page protectors as a measuring guide.

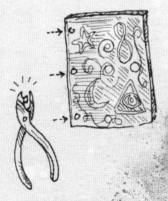

8. To prevent the soap-paint mixture from remaining tacky, mist or brush your covers with a coat of clear sealant or water-based glue-sealant. Allow the covers to dry completely.

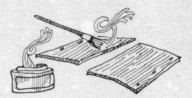

9. Thread the back cover onto the binder clips. Fill your grimoire with page protectors for collecting color ephemera and paper for recording your magickal impressions.

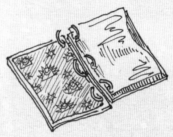

10. Thread the front cover through the binder clips and snap the clips closed.

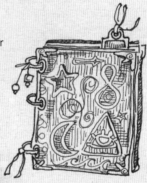

VARIATION

You may wish to embellish the corners of your scratchboard cache with book corners. These little corner covers are available online and at your local craft shop. Book corners come in a wide variety of finishes from metal to wood and add a personal detail to your magickal records.

DISCOVER CORRESPONDENCES

Correspondences are the keys to unlocking the world of color magick. In this quest, you will build upon the magickal knowledge of those who have come before and develop your own bank of color wisdom from which to draw inspiration and forge connections with the universe. Let us tap into new senses, riff on memory, and explore the mysteries of correspondence.

TO CORRESPOND

In magickal circles, correspondences refer to the way places, plants, stones, animals, scents, entities, elements, metals, and colors organize around an idea and relate to one another. Objects, planets, plants, scents, and colors that correspond share a common energetic thread that runs through time and space, and some believe connect the magician to the realms of the supernatural.

The concept of sympathetic correspondences gained popularity with 15th and 16th century magicians inspired by Hermeticism and Neo Plantonism. Their interest in and experimentation with correspondences contributed to the beginnings of modern chemistry and medicine. You are a continuation of this lineage of curiosity!

Magicians of the 19th century compiled lists of magickally related items as tables of correspondence. These lists of correspondences are still used today and are usually presented as charts intended for contacting entities in formal ceremonial magick rituals but are most often utilized by sorcerers to select ingredients for spell craft.

For our purposes, correspondences are personal and cultural connections to the language of color. For instance, we might find that green is associated with the planet Venus, personal growth, and healing magick. We then draw from our personal experiences and notice that green makes us feel relaxed, tastes tart like key lime pie, or triggers a fond memory of summers stretched out in dewy grass gazing at the stars. We can use all these insights as links to the correspondences of green for use in our rainbow magick.

We can think of correspondences as energies that rhyme and harmonize with one another and become a matrix of communication for the Rainbowmancer.

You may be asking, why bother creating correspondences if there are already scores of charts available? Aren't we reinventing the wheel? Working spells or creating art based solely on the experiences of others versus your own experimentation is a bit like the difference between reading an article about scuba diving and donning a tank and flopping into the salty deep yourself. While the scuba diving article may provide important information about diving safety or recommend choice locations to explore, you won't meet an inquisitive clown fish face to face or experience the weightlessness of the sea. Don't stop your explorations at the edge of someone else's reporting. Take the plunge. Get wet. Make your own discoveries. There be treasures here.

How To Create Correspondences

The prompts in the following list are suggestions to help plumb the depths of your experience and create your own color correspondence insights. Expand on these prompts in any direction your genius wishes to lead you. Deepen your relationship to the rainbow by spending time in conversation with each color. You may wish to journey through your correspondence creation one color at a time, spending a day with each. Conversely, you may enjoy conjuring up a colorful brainstorm and let sensory memories rush through you in a great wave. Ride it! Use initial instinctual responses to start, then allow each color to marinate in the alembic of your imagination. Meet whatever insights percolate to the surface with friendly curiosity. You can always add to and revise your correspondences as you work with color magick. Nothing is permanent. All is subject to frequent and joyful revision.

* What flavors do I associate with this color?

* What scents does this hue exude?

* Are there textures I connect to this hue?

* Do I have any strong memories or mental images where this color makes an appearance?

* If this color were expressed as a sound, what would it be?

* Are there any stones, minerals, plants, creatures, planets, or entities that contain or are allied with this color?

* What kind of power emanates from this color for me?

* Are there any other details or sensory impressions I intuit?

SENSORY SORCERY

Use your memories, associations, and intuition to conjure up and establish your own correspondences in a way that is meaningful to you. Not only will this experimentation be a riot of sensory fun but will foster the development of your visual language. This is a creative signature unique to you.

Prompts for sparking
Correspondences

Color

Flavors

Scents

Texture

Memories

Sounds

Stones

Plants

Animals

Powers

Enjoy watching your web of color correspondence connections flow from the far reaches of your imagination and rendezvous at the tip of your pen in the present moment.

TRICKS FOR COLLECTING CORRESPONDENCES

Let's explore techniques for visually organizing your correspondence discoveries. Play with, mash, and remix one or all of these organizing devices to see which reveals the most potent results for you.

Spider Webbing

Anchor your web with a color as the core concept and fill in the space around it with offshoots containing information and insights related to the core color. This is a non-hierarchical sprawling technique, similar to mindmapping, ideal for fast moving brainstorms with plenty of opportunity to add additional insights as they arise.

Pictograms

A pictogram is a drawing or doodle. You can organize your correspondences by creating simple illustrations of your thoughts about a particular color. Pictograms make our imaginings visible and help us see complex ideas. It is also great fun to make lots of tiny drawings.

Collage

Gather found or printed images related to a specific color and create a collage of correspondences. Snip pages from magazines, craft your own paper collage ephemera, or compose a digital collage.

Free Write

Zone out, daydream, and let your imagination meander. With pen in hand, write your correspondences as a stream of consciousness like a cosmic poet. Give this process plenty of space and you'll be stunned by your brilliant channellings.

EMBARK ON A SCAVENGER HUNT

Foraging for color in the wild awakens us to a vivid world full of changing gifts. Rainbow scavenger hunts combine the skills of observation, divination, and keen mindfulness to reveal synchronicities and lead the Rainbowmancer on helpful adventures. Just beyond your front door lie fleeting treasures, and beauty yet to be discovered. Happy hunting!

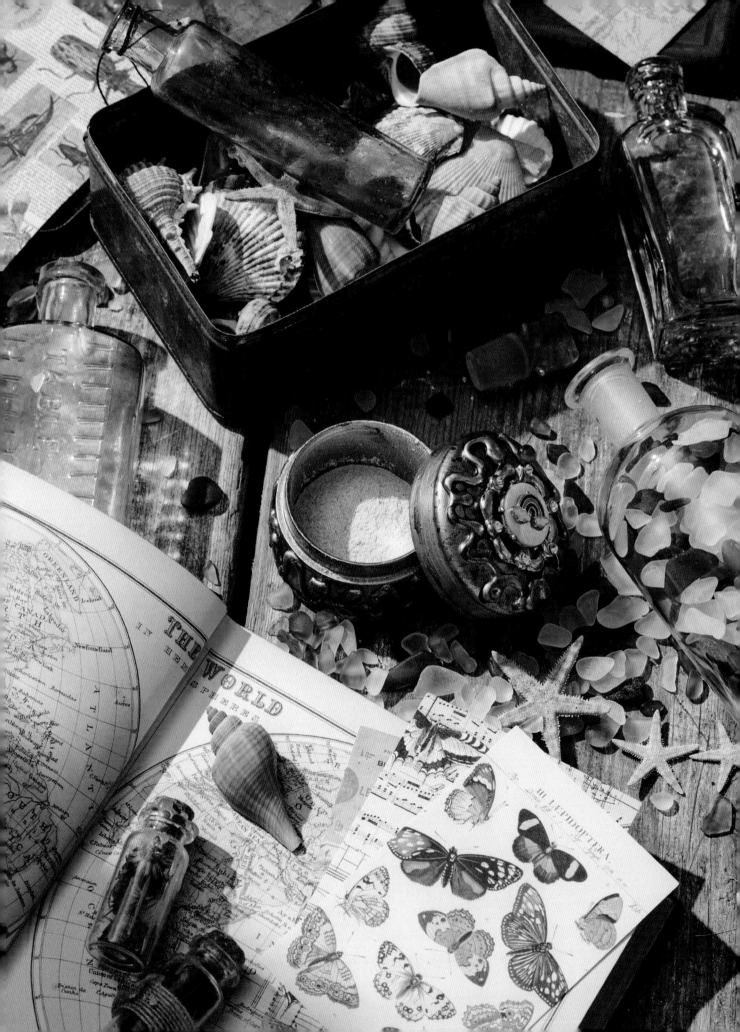

SEARCH FOR THE RAINBOW

Scavenger hunts instantly transform you into an explorer. This quest strengthens our perception and takes us into the field on an observation safari. Go out into the world with the intention of meeting color and notice once hidden wonders emerge from the margins. Added side benefits of scavenger hunts include being out and about in the community, a deeper enjoyment of your surroundings, and neutralizing negativity bias. These hunts make for excellent solo magickal dates or small group adventures. Document your scavenger hunt findings with a camera or leave your phone at home and forge ahead with a mini sketchbook to note your discoveries.

Rainbow Chase

Venture out with the intention of meeting each color of the rainbow: a red car, a jogger sporting yellow sneakers, an orange poppy. Seek until you have met every color in the rainbow. Perform this hunt regularly as a form of walking meditation and fine tune your rainbow magick powers. Aim to find fresh expressions of each color every time you go rainbow chasing. Record your encounters in your color cache.

Monochrome Mission

Choose one color to track. While on your hunt, gather as many examples of your chosen hue as you can. This could be a hunt for pink, found in salmon denim shorts, magenta bergamot blossom, a baby pink Cadillac, a puppy's tongue, earth worm, bakery donut mural, June flox, watermelon slice in the crisper drawer. Stretch the edges of your Rainbowmancer capacity to find an abundance of monochromatic riches. Add your monochrome mission findings to your color cache.

Seasonal Sojourn

Go on a quest for seasonal hues. Use the rainbow as a guide to search for hyper-local colors that express themselves in a particular season. For example, your hunt might be called "Early Summer on Ward Street" and you find: red in a fresh rhubarb patch, orange in an iris beard, yellow as a fat bumble bee, green as a watering can in your neighbor's garden, and so on. Perform this quest for each of the four seasons and other times of the year associated with your locality, like the first week of harvest, a festival of the arts, or Strawberry Moon season. Specificity will make these collections challenging and captivating. Record your seasonal sojourn themes and discoveries in your color cache.

Sacred Support

Are there colors that hold significance in your spiritual, religious, ancestral, or cultural traditions? Perhaps there are colors that are important to a cause close to your heart or symbolically relevant to your community? Set out on a walk to seek these special hues in the field. What kind of scavenger hunt could you create for communal support? Go on sacred support scavenger hunts to be spiritually nourished, communicate with your lineages, and meditate on solidarity and connection. Document any insights that arise in your color cache.

Curiosity Collections

This scavenger quest involves collecting physical tokens of color as collections like pebbles, shells, fabric scraps, bottle caps, figurines, micro plastic refuse, sea glass, wildflowers, or leaves. Bring a jar, bag, or tin to store your treasures. You may wish to collect the entire rainbow in an outing or focus on a monochromatic mission. These color curiosity collections are excellent additions to your color altar, creative projects, and color caches. Collector beware: these prizes are magnetic and are likely to multiply exponentially over time. If one is short on space, this scavenger quest may be performed as a "catch and release" hunt.

SUGGESTED LOCATIONS FOR COLOR FORAGING

Your Rainbowmancer Sight can be switched on anywhere at any time. Here are a few choice locations to practice color scavenger hunting.

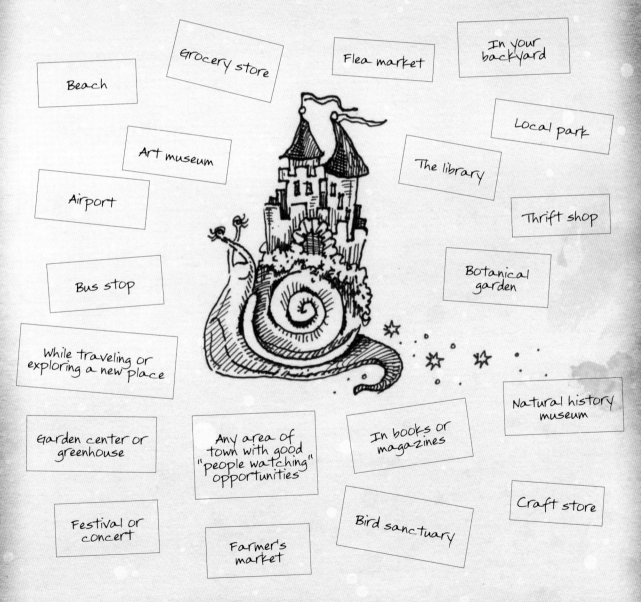

Grocery store

Flea market

In your backyard

Beach

Local park

Art museum

The library

Airport

Thrift shop

Botanical garden

Bus stop

While traveling or exploring a new place

Natural history museum

Garden center or greenhouse

Any area of town with good "people watching" opportunities

In books or magazines

Craft store

Festival or concert

Bird sanctuary

Farmer's market

The Rainbowmancer's Map

Document locations that awaken your rainbow magick senses in the form of an enchanted map. These locations may be local places you visit regularly, travel destinations, or memories from the past. Maps care little for rules and are happy to defy the constraints of space and time.

Let's pretend your map includes a fantastic Mexican grocery store housing a flock of piñatas, a hidden alley with a vibrant jaguar mural, a resale boutique that organizes its wares by color, a Victorian painted lady with coral trim, the pier where they fly dragon kites and set off fireworks, a blazing Japanese maple, and a star marking every riotous magenta crab apple tree in your local area. Use a map you've printed or illustrated yourself to record these inspiration locations. Become a color cartographer and explore the geography of your imagination.

Tips for Scavengers

When performing scavenger hunts, it can be helpful to try softening your gaze and allow the scene to go hazy. This misty perspective aids receptivity to colors and light. Another classic magician's trick is to occasionally focus on your periphery vision. You can do this by feeling into what it might be like to view the world as a deer or owl with a broad range of vision. It is said that the peripheral field is where the unusual and anomalous reside. Enjoy exploring the fringes.

The skilled magician also knows the importance of reciprocity. Reciprocity is an exchange of mutual benefit. Acts of reciprocity are acts of being in good relationships, and we are Rainbowmancers with excellent manners. When wandering the world seeking insights, harvesting, connecting to the genius loci (the spirits of place), or collecting something, it is good practice to give an offering. Even if you don't work with or believe in spirits, you will be nourished by the practice of gratitude and more fully recognize what is being received. What follows is a recipe for a Rainbow Magick on-the-go offering powder to tuck in your satchel for impromptu gift giving in the field.

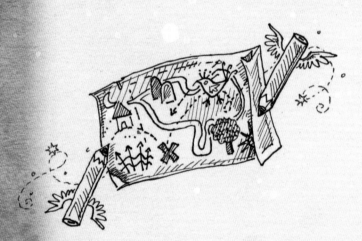

On-The-Go Offering Powder

This bright biodegradable powder is ideal for offerings and communication with color guides. This powder may also be mixed in larger quantities to infuse spell work, photoshoots, and celebrations with color magick.

YOU WILL NEED

+ Mixing bowl
+ ½ cup (60g) cornstarch
+ ¼ cup (60ml) water
+ Food coloring in one color (use paste or gel for a bold color, liquid for a pastel color)
+ Whisk
+ Foil pan or paper-lined baking sheet
+ Food processor or blender
+ Biodegradable additions like spices, dried herbs, or flower petals
+ Container for your completed offering powder, such as a tin, bottle, jar, or resealable bag.

1. In a bowl, add the cornstarch, water, and desired food coloring.

2. Whisk the cornstarch mixture until the color is thoroughly distributed.

3. Spread the mixture into the pan in a thin layer to dry. Depending upon your climate, this may take several hours or several days. Occasionally break up any clumps in the powder with a fork.

4. Once the colored cornstarch is thoroughly dry, transfer it to a blender. Add any biodegradable items you would like to include in your offering powder. Whizz the mixture in the blender until a fine powder is achieved. Grind in a pestle and mortar for extra occult effect.

5. Decant the offering powder into a container of your choice. To prevent mold growth, be sure your powder is completely dry before storing in a sealed container.

Using Your Offering Powder

When beginning a scavenger quest, sprinkle a spoonful of offering powder into your palm. Say to yourself or out loud: "May all that I seek, seek me. May I see all that sees me." Or use any words you make up that feel heartfelt and honest. Blow the offering powder out of your hand, out the front door, and into the breeze. You are ready to begin hunting.

When harvesting color curios, sprinkle your offering powder on the spot you collected from as an act of gratitude, where appropriate. It would also be appropriate to pepper a place of inspiration as thanks for intellectual, artistic, or spiritual nourishment.

Feed your altar or candles with an occasional dusting of offering powder as a form of blessing and building energy.

Offer your well wishes and aspirations for your loved ones, community, and the world with a prayer or incantation. See the powder transforming into a cloud to be carried to its target. Activate the spell by releasing the powder into the wind.

BEFRIEND YOUR COLOR GUIDE

What if you had a magickal mascot to cheer you on? A fun-loving advisor to collaborate with in your creative sorcery? Or maybe a mystical template to support your next step? You, Rainbowmancer, can create one. In the following pages you'll discover how to identify, meet, and play with your own personal Color Guide.

FIND YOUR GUIDE

Now that you have wandered through the rainbow menagerie, quested for color in the wild, and assembled your own magickal log of personal correspondences, it is time to choose a Color Guide. This Color Guide will act as a friend, genius, and familiar to assist you in developing your skills as a Rainbowmancer. A Color Guide is a color of power: a source of personal energy, guidance, and focus. You may find you have more than one Color Guide. It is also highly likely that your Color Guide will change over time as the spirits of color ebb, flow, and evolve as we do. The following are suggestions for how to choose your Color Guide and initiate your magickal relationship.

Gut Feeling

If upon perusing Meet the Rainbow, at the start of this book, any of the color descriptions sparked your imagination, wrapped around your heart, or gave you a giddy sensation, this is a message to explore further. Tune in to any bodily sensations or subtle feelings that bubble to the surface as they are signals to initiate a relationship with your Color Guide.

Aspiration

There may be a specific sphere of your life you currently wish to alter. Select a color that aligns with your current desire to bring focus to this area of concern or edge of personal growth. For example, to hone writing skills and free my voice as a writer, I could choose to ally with orange. Or to aid my goal of boosting physical well-being, I could choose to partner with gold for vitality and support in making healthy choices. Choose a goal, wish, or intention and pick a Color Guide with the skills to assist you.

Instinct

If you have a favorite color that appears in your environment repeatedly or fills you with glee, lean in and claim it. Our Color Guide may come forth simply through recognition of our own patterns and preferences. Magick is allowed to be easy. The most powerful magick is that which comes to us naturally! If you do possess a favorite color and obvious Color Guide, get curious about which variations of that color speak to you the most clearly. For example, if pink raises its hand, get curious about flamingo pink, petal pink, or watermelon pink. Specificity will invigorate your relationship with your Color Guide.

Mirroring

Are there any color descriptions that paint a portrait of you? Are you intuitive and quirky like lavender? Are you soft and loyal like brown? Or are you deep and stormy like navy blue? Use the color descriptions as an imaginary "want ad" for your Color Guide and build your partnership with a color that mirrors your personality.

I found that I could say things with color and shapes that I couldn't say any other way – things I had no words for.

Georgia O'Keeffe

Visualization

If you are unclear on your Color Guide or wish to strengthen your connection, loosely and playfully consider this brief visualization:

You have received a distinguished invitation to join the great convocation of Rainbowmancers, art witches, and color wizards from around the world. As you prepare to teleport yourself to this powerful gathering of prismatic sorcerous beings, you see yourself transforming into your most exalted Rainbowmancer form...

✶ Do you have an aura?

✶ Do you emanate a spectrum of color?

✶ Do droplets of technicolor dew roll off your eyelashes?

✶ What colors are your skin, eyes, and hair?

✶ What garments are you wearing?

✶ What tools or talismans do you wield?

✶ Do you leave a snail trail of rainbow dust or aqueous puddles of color in your wake?

✶ Does your voice have a color, texture, or density when you speak?

Roll this image around in your mind's eye like a juicy hard candy, slowly savoring it until something shows up that really delights you. Record this helpful intelligence about your Color Guide in your color cache.

COLOR GUIDE INITIATION BOTTLE

Invoke your Color Guide and usher in your new era of rainbow magick with a Color Guide initiation spell bottle. Create this bottle to house a physical reminder of your Color Guide and anchor your relationship in the material world.

YOU WILL NEED

+ Glass bottle or jar with a tight-fitting lid

+ Isopropyl alcohol or distilled water

+ Food coloring or alcohol ink in your desired color

+ Vegetable glycerin

+ Glitter, beads, or faux flowers

+ Mica powder or metallic liquid acrylic paint

+ Hot glue or sealing wax

1. Fill half the bottle with isopropyl alcohol. If you're using water, be sure to use distilled water to ensure your mixture won't get moldy.

2. Add drops of food coloring or alcohol ink until the liquid has reached your desired hue.

3. Slowly pour in the vegetable glycerin until the bottle is three-quarters full. The glycerin slows the movement of objects in the bottle. You can adjust the amount of glycerin later if you desire a more viscous potion.

4. Sprinkle a spoonful of glitter, beads, or faux flower petals into the bottle, in whatever combination pleases you.

5. Add a dash of mica powder for shimmer. Start conservatively and add slowly as too much mica powder will make your mixture opaque. If mica powder is unavailable, metallic and iridescent liquid acrylic paints contain mica powder. Squeeze a small dollop of liquid acrylic paint into your bottle as a mica powder replacement.

6. Tightly seal the lid. If using a bottle, use a rubber cork to keep your spell bottle safely sealed and prevent any mold and evaporation.

7. Finish the bottle with a generous blob of hot glue or sealing wax for an extra enchanting effect. Your Color Guide initiation spell bottle is ready for Rainbowmancy!

TO USE YOUR SPELL BOTTLE

Place the bottle on your color altar. Give the it a shake when you wish to commune with your Color Guide, summon the qualities of your guide, or refresh your rainbow magick focus. Gaze into the swirling depths for meditation or rainbow magick scrying.

BUILD A COLOR ALTAR

As your curiosity for casting rainbow enchantments grows, you'll need a place to set up shop. An altar is that workshop. This space is a carnival of meaningful objects, collections, intentions, wishes, and inspiration. Let's tinker to build your own personalized and dynamic space for slinging rainbow spells.

PORTAL OF FOCUS

Altars are an outward expression of the inner realms. Altars represent what is important to us at the time of their creation. These curated spaces are portals of focus amid distraction and a direct line to entities, ancestors, and energies. Altars appeal to our aspirations, feed us with beauty, carry prayers, and connect us to our spiritual lineage. We may work with an altar for meditation, cultivate healing solitude, or simply to be surrounded by things we enjoy. All altars express our creativity and reflect our desires. Most importantly, altars are fun to make.

Our next quest is to create an altar to bolster your creative powers and commune with your current Color Guide. While some spiritual traditions have specific guidelines for where and how an altar should be built, in rainbow magick the size, scale, and complexity of your altar is entirely up to you. We can approach altars as purposeful collections. There is no incorrect way to purposefully collect. If you make an addition to your altar that feels a bit unhinged or irreverent, you're on the right track and likely on the verge of something very interesting. Remember, nothing is permanent and frequent revision keeps your magick fresh.

Choose a color or color scheme

You may wish to dedicate this altar space to your current Color Guide or choose a scheme that speaks to your desired adventure, intention, or feeling.

Choose a location

Next, choose where your color altar will live. Windowsills, bookshelves, side tables, countertops, and dressers are excellent altar locations. Altars may also present as containers: shoe boxes, suitcases, platters, trays, or wall niches. If space is available, get decadent and devote an entire wall of your studio or a closet to your altar construction. Choose a location that works with your lifestyle. Experiment with the placement and footprint of your altar, allowing its edges to be elastic until you find out what delights you both. Be generous with your play.

Purposeful Collections

Gather items for your altar that feel magnetic to your cause. An altar dedicated to the rainbow may look like a jubilant array of items and contain a banquet of color. A monochromatic color altar dedicated to a Color Guide will be populated by objects of one colors. If you are stuck as to what to include on your altar or need permission to play, here are a few suggestions to get you started.

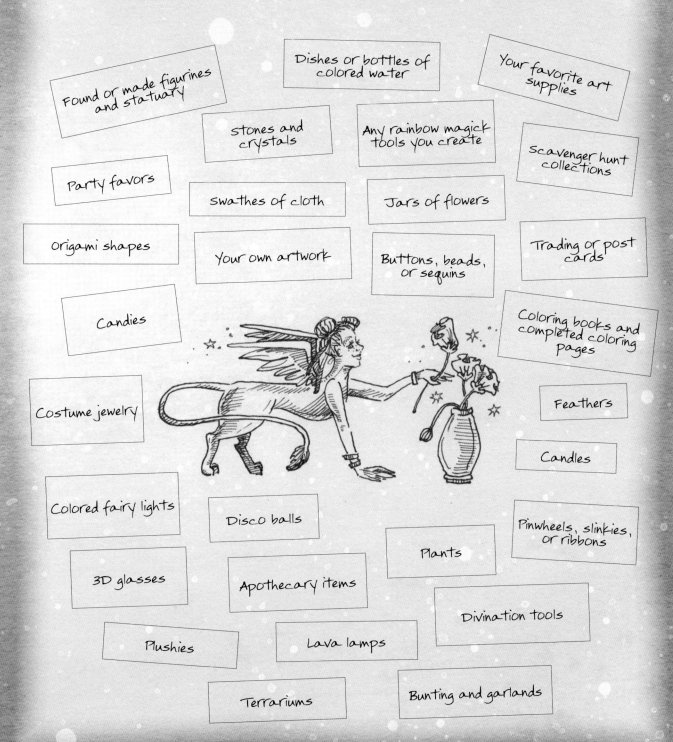

Found or made figurines and statuary

Dishes or bottles of colored water

Your favorite art supplies

Stones and crystals

Any rainbow magick tools you create

Scavenger hunt collections

Party favors

swathes of cloth

Jars of flowers

Origami shapes

Your own artwork

Buttons, beads, or sequins

Trading or post cards

Candies

Coloring books and completed coloring pages

Costume jewelry

Feathers

Candles

Colored fairy lights

Disco balls

Pinwheels, slinkies, or ribbons

Plants

3D glasses

Apothecary items

Divination tools

Plushies

Lava lamps

Terrariums

Bunting and garlands

Invite Avatars of Color

Experiment with including images of cartoon, comic book and graphic novel characters who inspire you to live colorfully on your altar. Images of entities like Iris, the Greek goddess of the rainbow or god forms related to your tradition may also be appropriate. Invite the presence of other Rainbowmancers living and dead in the form of artists, designers, illustrators, filmmakers, poets, and visionaries who inspire you to see and feel more. Which color avatars would you invite to share your altar space?

Rainbow Altar Crafts

An element of the unexpected is essential for the altar of a Rainbowmancer. The following crafts are examples of ways to infuse your altar with play, personality, and your own magickal signature.

With color one obtains an energy that seems to stem from witchcraft

Henri Matisse

CRAYON-DIPPED CONFETTI CANDLES

These painterly candles bring plenty of color and a dash of unpredictability to the altar through the use of crayons. Create candles for sacred decoration, candle magick spells, offerings, and celebrations.

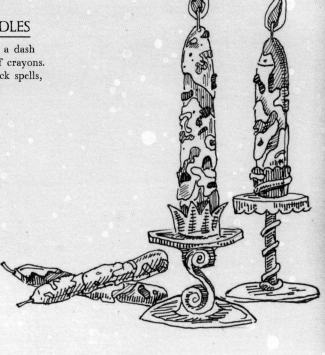

YOU WILL NEED

+ Glass jars or tin cans (one for each color you wish to mix)

+ Handful soy wax flakes or chopped up recycled white candle wax

+ Crayons

+ Baking sheet

+ Wooden skewer or spoon

+ White taper candles

+ Waxed paper

+ Pencil sharpener

1. Preheat the oven to 200°F (90°C). In a glass jar, add the soy wax flakes and half an unwrapped crayon in the color of your choice. Repeat this process in a new jar for as many colors as you wish to layer onto your taper candles.

2. Arrange the jars on a baking sheet and place them in the oven for 10 minutes or until the wax flakes liquefy.

3. Remove the baking sheet from the oven and carefully stir the hot wax with a wooden skewer until the melted wax and crayon wax are fully incorporated. Adjust the color saturation by adding more crayon wax if you wish.

4. Allow the melted wax to stand for a few minutes. Next, dip the end of the taper candle into the melted wax. Allow each layer to harden for a few seconds before dipping the taper again. Repeat dunking the taper until the colored wax reaches the opacity you desire. Allow the wax to harden.

5. Next, place a piece of waxed paper onto the baking sheet. Using a pencil sharpener to create crayon shavings, scatter bits of crayon wax onto the waxed paper. Note that too many crayon colors will result in a muddy mess. Start with two or three colors. You can always repeat this step to add additional layers.

6. Place the baking sheet in the oven for one minute, just until the crayon wax gets shimmery. Remove the baking sheet from the oven.

7. Carefully roll your dipped taper candle across the surface of the waxed paper. The wax shavings will stick to the taper candle giving it a lovely painterly finish.

8. Repeat steps 5 through 7 until your candle pleases you!

Home-Grown Crystal Votive Holders

Enter the color alchemist's lab and cook up one-of-a-kind couture crystal furnishings for your altar. Grow your own crystals in every color of the rainbow. Enhance this spell by meditating on what treasures you'd like to grow in your own life while simmering your crystal solution.

YOU WILL NEED

+ Pipe cleaners

+ PVA glue

+ 2 cups (475ml) water

+ Saucepan

+ ¾ cup (226g) alum powder

+ Food coloring

+ Glass jar

+ Craft wire

+ Spoon or wooden skewer

+ Clear coat acrylic spray (optional)

+ Gold paint

+ Tea lights

1. Form several pipe cleaners into a loose cup shape. The crystals will add bulk to the pipe cleaner form, so make the cup a little deeper and wider than a standard tea light. Coat the pipe cleaner cup with PVA glue and allow it to dry completely.

2. In a saucepan, bring the water to a boil.

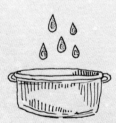

3. Turn off the heat. Incorporate the alum powder into the water gradually, stirring well until the powder has dissolved.

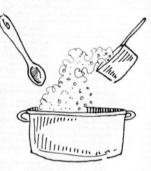

4. Add a generous splash of food coloring. Transfer the solution to a glass jar. Your crystal growing solution is ready.

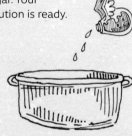

5. Suspend the pipe cleaner with a piece of craft wire wrapped around a spoon or wooden skewer.

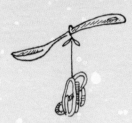

6. Dunk the pipe cleaner form into the hot alum water solution, making sure the pipe cleaner is entirely submerged. The pipe cleaner should be suspended freely. Allow the it to rest in the solution overnight.

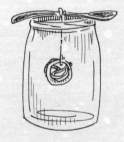

7. Remove the crystal-covered pipe cleaner from the solution and place it on a paper towel to dry.

8. Once the crystal is completely dry, you may wish to coat it with a clear coat acrylic spray to protect it from damage or fading.

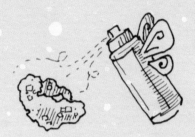

9. Finish the bottom of your crystals with a coat of gold paint to create a geode effect.

10. Place a tea light in your crystal votive holder and enjoy your sparkling rainbow gems.

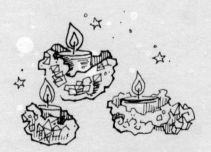

Psychedelic Spin Art Rainbow Caller

Create a spin art talisman to invite the spirits of color to collaborate in your creative magick and sanctify your altar as a fully functional enchantment workshop. Whether gleaming by candlelight or throwing rainbows about the room on a sunny day, playful etheric presences (including you) will be unable to resist your beatific offering. Use this technique to create all manner of surprising objects to remember the colorful everchanging universe within you.

YOU WILL NEED

+ A few CDs (minimum of 3)

+ Liquid acrylic paint in various colors

+ Salad spinner (one you don't intend to use for salad post project)

+ 2 to 3 marbles or small stones

+ Scissors

+ Hot glue

+ Ribbons in a variety of colors

3. If you love the results of your spin, set the CD aside to dry completely. If you don't love the results, squeeze in more paint, and keep spinning until you are satisfied. Repeat this step for the other CDs.

1. Place a CD shiny side up inside the salad spinner and squirt a few dollops of liquid acrylic paint onto the surface of the CD.

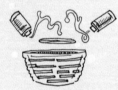

4. Using a pair of sturdy scissors, carefully cut one of the CDs into assorted shapes: crescents, rays, stars, squares, diamonds, or abstract shapes that appeal to you.

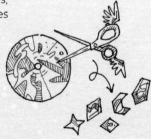

2. Toss the marbles on top of the salad spinner and close the lid. Let it rip!

5. Next, cut another CD into triangular shapes. These triangles will create a halo around the central CD.

6. Hot glue the triangular ray shapes to the back of the third CD.

7. Cut the ribbons into varying lengths.

8. Using hot glue, stick the cut shapes to the bottom of the lengths of ribbon.

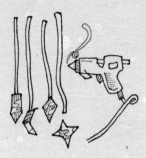

9. Adhere the lengths of ribbon to the back of the central CD.

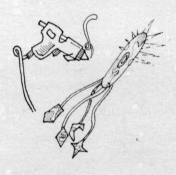

10. Finally, loop a ribbon through the center of the CD and hang in your color altar.

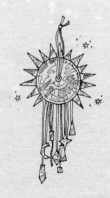

PREPARE A RAINBOW FEAST

Feed the eyes, heart, and imagination with an enchanting spread of luscious edible spells. Preparing, eating, and sharing color magick through food is perhaps the most deeply satisfying of rainbow magick rituals. Use these recipes to inspire your own therapeutic edible spells and nourish your favorite people with celebratory care-filled fare.

SPELLS

Let us adventure into the realm of food and the banquet hall of edible spells. We eat with our imaginations, experiencing sensation, memory, and anticipation long before our tastebuds get involved. The color of food can hint at its more secretive, hidden metaphysical properties.

We can begin our feast by simply consuming colorful foods that correspond with our magickal aims. Perhaps you're cocreating magick with pink, so watermelon may be a food ally to consider. Maybe to support your adventures with orange, you nibble on tangerines and sweet potatoes. In this quest, we will continue adding layers of meaning and flavor to our magick by cooking up a wide range of technicolor delights and dabble in the epicurean edges of rainbow magick.

Color-Focused Fare

Monochromatic menus are a potent form of color magick. From *amuse bouche* through dessert and bewitching beverages, dip into these suggestions to inspire your own decadent rainbow recipe creation.

+ **Red:** parmesan stuffed cherry tomatoes, strawberry mint salad, beetroot and goat's cheese Napoleons, red velvet truffles, and sparkling sangria.

+ **Orange:** mango peach salsa, stuffed squash blossoms, freshly pickled carrot and cabbage salad with tart orange vinaigrette, spicy roasted pumpkin soup, dark chocolate drizzled orange peels, and blood orange mimosas.

+ **Yellow:** turmeric pickled deviled eggs, fresh pasta salad, stuffed roasted yellow peppers, lemon sorbet served in lemon peel, and grilled pineapple mojitos.

+ **Green:** green pea hummus with toasts, stuffed grape leaves, dill cucumber salad, savory spinach crepe topped with microgreens, key lime pie, and green tea prosecco spritzer.

+ **Blue:** butterfly pea flower rice onigiri, blueberry spinach salad with blue cheese crumbles, blue corn polenta with edamame succotash, blue coconut tart, and blueberry bubble tea.

+ **Violet:** red cabbage and walnut salad, seared plums, purple cauliflower soup, purple sweet potato gratin, blackberry cheesecake bites, and wild violet infused lemonade.

+ **Pink:** radicchio and grapefruit salad, butter roasted radishes, beetroot gnocchi with brown butter, and hibiscus rosewater chiller.

+ **White:** garlic and lemon white bean dip, white cheddar fondue, pickled daikon radish salad, roasted white asparagus, white chocolate macaroons, and refreshing iced coconut punch.

+ **Black:** marinated olives, black radish, squid ink pasta with fresh muscles, black sesame brittle, and activated charcoal with blackberry mocktail.

+ **Brown:** rye tea toasts with onion jam, broiled balsamic mushroom caps, wild rice pilaf with pecans, walnut stuffed baked apples, drinking chocolate, and espresso.

Natural Food Dyes

One of the great joys of exploring Rainbowmancy in the kitchen is learning to wield natural food colorings for delicious and enchanting effect. From hummus to pasta to cakes to smoothies, kick up any rainbow magick recipe with assistance from these naturally occurring color allies.

+ **Red:** beetroot juice, pomegranate juice

+ **Orange:** paprika, red pepper, carrot juice

+ **Yellow:** ground turmeric, saffron

+ **Green:** matcha powder, spinach powder, fresh parsley

+ **Blue:** butterfly pea flower powder or tea, spirulina, red cabbage

+ **Violet:** freeze-dried blueberry powder, acai powder, blackberry juice, baked purple potato

+ **Brown:** espresso, coco powder

+ **Black:** squid ink, activated charcoal powder

+ **Pink:** cherry juice, beetroot juice

Suggestions for Powerful Snacking

Once you have selected an edible ally that corresponds with your aspiration you can further fuel your color magick with a meaningful ritual.

Write or freestyle an improvisational prayer or invocation. State the qualities and properties of the color you wish to see in yourself. Offer gratitude to the food and your Color Guide for their assistance and influence. As mentioned in previous quests, good manners go a long way.

Consider the time of day you plan to eat your color spell. You may wish to snack on your color crudité casually throughout the day as ambient magickal support, or you may consider a time of day that feels meaningful. A golden pineapple smoothie for energy and optimism would pair powerfully with the sunrise. A creamy purple cauliflower soup sprinkled with star crackers adopts a new complexity when eaten by candlelight as dusk falls.

Dine at your color altar as a form of ritual. While enjoying your edible spell, eat slowly and stay tuned in for any sensations, ideas, or messages you receive as you sup. Give yourself the time and space to truly enjoy and absorb this experience. What images, feelings, and insights arrive through sacred dining?

Rainbow Smorgasbord

The following recipes are sweet and savory suggestions to inspire your color feasting, helping you become a magickal culinary adept. Adapt these recipes to your liking and pen your own inspired *bon mots* in your color cache. Relish in the pleasure of brewing and simmering your own spells to nourish body, mind, and magick with rainbow feasts. *Bon appetite!*

SERENDIPITY SPRING ROLLS

Fresh and crunchy, these colorful spring rolls are stuffed with the restorative energies of the rainbow. Filled with the goodness of raw veggies and charming blue noodles, Serendipity Spring Rolls are high energy pockets of delight perfect for suppers, picnic lunches, or your next enchanting soiree. Serve chilled with a dipping sauce. Makes approximately 10 plump spring rolls.

YOU WILL NEED

+ Small head of red cabbage

+ 6oz (170g) instant rice vermicelli noodles

+ 8¾in (22cm) round rice papers

+ Sesame seeds

+ Radishes, sliced thinly into rounds

+ 2 medium carrots, cut into matchsticks or ribbons

+ ½ cucumber, sliced thinly into strips

+ 1 yellow bell pepper or yellow radish, sliced thinly

+ Fresh spring mix

+ 2 ripe avocados or protein of your choice, sliced

+ Fresh green herbs of choice

+ Edible flowers like nasturtium, pansy, chive blossom (optional)

TO MAKE THE PERIWINKLE BLUE NOODLES

1. Fill a large a saucepan with water and bring it to the boil. Add ¼ head of red cabbage and allow the cabbage to cook until the water is blue.

2. Remove the cabbage and allow the water to cool slightly. Put the rice noodles in a large bowl and pour the hot water over them. Follow the manufacturer's instructions for cooking time.

3. Strain the noodles and allow them to cool before assembling your spring rolls. If you would prefer bright yellow noodles, substitute the red cabbage for a tablespoon of turmeric powder.

TO ASSEMBLE THE ROLLS

1. Prepare the rice paper by dipping into water according to the manufacturer's instructions.

2. Carefully lay the wet rice paper onto a cutting board, plate, or clean countertop.

3. Lay any edible flowers (if using) in a line across the center of the rice paper and sprinkle the paper with sesame seeds.

4. Next, lay down a few radish slices and carrot matchsticks, followed by the cucumber, pepper, and red cabbage. These colors will show through the rice wrapper when rolled.

5. Then, place a line of avocado down the middle of the veggie pile.

6. Top the veggies with a generous handful of blue noodles. Be bountiful with the noodles! Under stuffing will result in a sad roll. An overstuffed roll will look plump and delicious when compressed.

7. Add a handful of fresh herbs towards the edge of the wrapper closest to you.

8. Begin rolling the rice paper and use your fingers to keep your bevy of veggies in place. Fold the outside edges of the rice paper on top of itself to create a pocket. The rice paper will stick to itself. Continue rolling to seal the spring roll. Enjoy.

STAINED-GLASS SPELL COOKIES

Every witch needs a good sorcerous biscuit recipe up their sleeve and stained-glass spell cookies are superbly suited for casting subtle rainbow magick. You may wish to create your stained-glass centers in a variety of colors or zone in on a specific hue to support your wishes.

YOU WILL NEED

+ 1 cup (227g) unsalted butter at room temperature
+ ¾ cup (150g) sugar
+ 1 large egg yolk
+ 1½ teaspoons vanilla extract
+ 2 teaspoons finely grated lemon peel
+ 2¼ cups (270g) all-purpose flour
+ ½ teaspoon salt
+ 6oz (170g) hard candies in your preferred colors
+ Extra sugar for finishing

1. Beat the butter and sugar with an electric mixer until creamy. Then beat in the egg yolk, vanilla, and lemon peel.

2. Gradually add the flour and salt, mixing until the dough begins to form.

3. Divide the cookie dough into 3 equal sections and flatten the dough into disks. Allow the dough to chill for at least 4 hours.

4. While the dough chills, grind one color of candy in a blender or food processor, beat with a rolling pin, or grind in a mortar and pestle. Pour the ground candy into a small bowl and repeat for each color. Set aside.

5. Preheat the oven to 375°F (190°C) and line two baking sheets with parchment paper.

6. Roll out the chilled dough between two pieces of parchment paper. Using cookie cutters of your choice, cut out the cookie shapes. Then using a smaller round cutter (or bottle cap), cut a window in the center of each cookie.

7. Move the cookie cutouts to the lined baking sheets. Then, spoon the ground hard candy into the center hole of each cookie, filling the window until it is the same thickness as the cookie dough. Sprinkle lightly with a pinch of sugar.

8. Chill the cookies for another 15 minutes before baking. Bake for 8 to 12 minutes, until the cookies are lightly golden, and the ground candies have become a transparent window.

9. Remove from the oven and allow the stained-glass cookies to cool completely before removing from the baking sheet. Store your spelled cookies in a fetching airtight tin.

VARIATION

When rolling out the cookies, cut a small additional hole for threading a ribbon. Gift these cookies as charms, holiday decorations, or rainbow talismans, or use them in your own home.

Orgonite Ritual Bites

These trippy rainbow treats are inspired by orgonite, a manmade material composed of resin, quartz crystals, and metal shavings. Orgonite pyramids are purported to have the power to transmute harmful energies into positive energies. While this orgonite look-alike dessert may or may not rearrange your life force, it is guaranteed to lift your spirits.

YOU WILL NEED

+ Pyramid silicone ice cube tray or silicone candy mold

+ Cooking spray

+ 6 packets of 3oz (85g) jello (jelly) dessert mix in your preferred colors

+ ½ cup (118ml) yogurt or coconut milk

+ Sprinkles, food glitter, edible metallic flakes, edible sparkle dust, luster dust, or cake decorating sugar crystals

+ Flower essences, herbal tinctures, edible flowers, or color elixirs (optional, see the elixir section in Rainbow Apothecary)

1. Lightly spray the inside of the silicone tray or mold to ensure your orgonite bites will easily release from the mold. Wipe away excess spray with a paper towel. Too much oil will prevent the layers of jello (jelly) from fusing together.

2. Prepare one packet of jello using half of the water recommended in the manufacturer's instructions. If you would like to add any essences, tinctures, or luster dust, add a few drops now while the dessert is still liquid.

3. Allow the liquid to cool just slightly.

4. To create opaque layers, whisk a spoonful of yogurt or coconut milk into the liquid.

5. Pour a small amount of the jello liquid into the mold to create the first layer. Add a few larger sprinkles or luster flakes and allow the layer to set in the refrigerator for 15 to 30 minutes.

6. Repeat steps 2 through 4 with as many colors as you desire until your mold is full.

7. Refrigerate for at least 4 hours. Carefully remove the bites from the mold onto a chilled platter. Enjoy your psychedelic desserts for an inspired lift and to circulate life affirming rainbow magick!

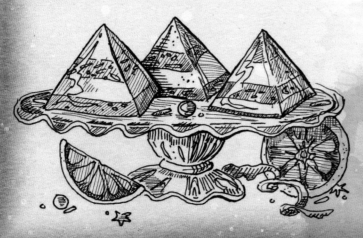

VARIATION
For extra firm, non-vegetarian orgonite bites, add a packet of baker's gelatin when mixing the jello.

Garden Goddess Cornbread

This delicious savory cornbread recipe serves up painterly seasonal beauty as vegetables are transformed into an edible tableau. Prepare as a main course or as a crowd-pleasing starter for celebrations. This bread pairs beautifully with flower butter. Makes approximately 16 servings of warm crumbly rainbow magick.

YOU WILL NEED

+ 1 cup (160g) fine cornmeal

+ 1 cup (120g) all-purpose (plain) flour

+ 4 teaspoons baking powder

+ 2 teaspoons celery salt

+ Pinch of pepper

+ ½ cup (45g) grated parmesan cheese

+ 2 eggs, beaten

+ 1¾ cups (414ml) milk

+ 4 tablespoons butter, melted

+ 1 small bunch scallions (spring onions), chopped

+ ½ teaspoon salt

+ Oil

+ Any combination of vegetables you love to decorate your bread, such as cherry tomatoes, asparagus, bell peppers of all colors, red onion, olives, chives, fresh herbs, and edible flowers

1. Preheat your oven to 375°F (190°C). Grease a 9in (23cm) square baking pan with oil.

2. In a large bowl, sift the cornmeal, flour, baking powder, celery salt, and pepper. Mix in ⅓ cup of parmesan cheese. Stirring is the perfect time to imbue your food with well wishes.

3. In a medium mixing bowl, beat together the eggs, milk, and melted butter.

4. Add the egg mixture to the dry ingredients, stirring gently until all ingredients are well incorporated.

5. Fold the chopped scallions into the batter and pour the batter into the oiled baking pan.

6. Sprinkle the rest of the parmesan cheese over the top of the batter.

7. Slice your chosen vegetables and coat them lightly with oil to keep them from charring in the oven. Arrange the vegetables on top of the cornbread mixture and sprinkle with salt.

8. Bake the cornbread for 30 to 35 minutes, or until the top of the bread is golden and firm, and the vegetables look deliciously cooked.

9. Cut the cornbread into generous squares and serve warm with butter.

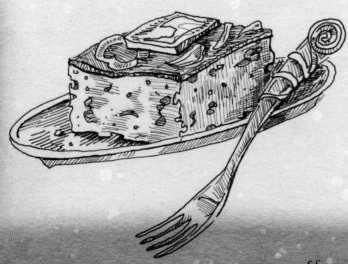

Design Enchanting Interiors

The lair of a Rainbowmancer is a sight to behold. Our living, working, and play spaces can be likened to altars as their care and design are acts of magick. Symbolism, visual poetry, correspondences, and design collide in a gratifying explosion of magickally informed personal style as we finesse and shape our own enchanting interiors.

SUBLIME DESIGNS

Our next rainbow magick quest will examine the art of constructing enchanting interiors. Whether your tastes tend towards atmospheric, austere neutrals or color-drenched caves, the following pages will conjure up design inspirations to trick out your sanctuary with color magick. It is time to become the architect of your dreams, Rainbowmancer...

A plush crimson rug to kiss your feet and bring you back into your body.

An indigo damask chaise lounge to encourage deep rest and afternoon trips to the astral.

A stained-glass window to spill friendly sunshine on the kitchen floor and the back of a snoozing cat.

A lick of rose quartz paint on the door frame because love is always just around the corner.

An amethyst light to play on the porch and assure the neighbors there is a witch in their midst.

As we set out to apply color magick to our living, working, and play spaces, we can consider:

+ What is this space for? How is it currently used?

+ How would I like this space to feel?

+ What story would I like this space to tell?

+ Where have I been, in real time or in my dreams, that offered my heart a sense of belonging?

Muse on the story of your dream space. Is it romantic, cozy, edgy, stimulating, mystical, rejuvenating, or formal? Once we understand our aspirations for a space, we can begin weaving design-focused color magick.

Aesthetics for Eccentrics

What is your personal design aesthetic? Are you drawn to traditional interiors? Modern, beachy, or vintage eclectic? Maybe you're into organic, bohemian, or Hollywood regency décor. Does art deco, industrial, modern, shabby chic, or Scandinavian style make your heart thump? Or are you most comfortable in a treasure-filled whimsigoth, maximalist, or rustic interior?

Maybe you're a marvelous magpie who celebrates eccentric undefinable design and laughs off labels. Taking a beat to reflect on what makes you feel at home is an excellent point from which to begin your color design dreaming.

Color Schemes for Spellbound Style

Let's investigate a few color schemes for effortless style and stunning magickal results.

Monochromatic: Monochromatic designs focus on layering tones and shades of the same color. Imagine a sage green room with an emerald velvet sofa piled with seafoam green pillows and a mossy knit throw. The limited palette of a monochromatic scheme keeps the energy focused and cohesive. The star hue will carry all communications. This scheme relies heavily on the use of textures and pattern to bring it to life.

Complementary: Complementary design schemes draw together two opposite mates on the color wheel. Imagine a terracotta room with a royal blue sofa, piled with orange pillows and a turquoise throw. Complementary scheme interiors are dynamic with high visual interest and balance.

Analogous: This scheme is a tight knit group of colors, relying on a primary color and at least two comrades on either side. Imagine a navy blue room with an indigo sofa scattered with allium purple pillows and throw. This particular scheme starts with blue and moves through indigo and violet. Analogous schemes tend to present luxuriously with a harmonious sophisticated feel.

Palettes for Enchanting Interiors

Jewel tones: These colors range from bright to dark highly saturated hues. Jewel tones will often have names inspired by gemstones like ruby, sapphire, or emerald. Jewel tones read as rich, playful, moody, and dramatic.

Pastels: Pastels are any color with the addition of white that makes them feel luminous and sugary. These colors tend to be soothing, subtle, and youthful and work well in any space you wish to convey an air of softness.

Earth tones: This is an unscientific but visually accurate description of colors we associate with nature. These colors will reference natural materials like wood and stone, and draw inspiration from the landscape and outdoor motifs. Earth tones communicate an organic, muted character with grounding properties.

Neutrals: Neutrals are desaturated colors that don't appear on the color wheel. Examples of neutrals are beige, grey, black, and white. These colors tend to be versatile and practical, promoting a relaxing atmosphere. For Rainbowmancers who regularly remix their spaces, the flexibility of neutrals could make them an appealing choice for large furniture pieces or wall colors.

Color Stories

Color stories are a way to consider schemes and palettes more sensually. When crafting a color story for a space, we can take temperature into consideration: Is our color story warm or cool? Warm color stories energize and impassion, while cool color stories soothe and collect. When selecting a color story for your space enchantments, be inspired by what you love and sense impressions that blossom in your mind...

A crystalline-inspired story that draws from your love of high fantasy tales of childhood.

A neon desert color story that harkens to your holographic galaxy skipping alien alter ego.

An organic dark and moody story whispers to reach the gnarly bog witch in your heart.

Ponder your favorite season, your favorite restaurants, or a dimension you visit regularly that feeds you. What details make these places special? Note these fragments in your cache to incorporate into your own designs.

COLOR-CONSCIOUS DÉCOR

Now that we've assessed our aspirations and selected a color story, it's time to dive into color conscious décor and fearlessly create our spaces.

Painting and Wall Treatments

Paint is the Swiss army knife of rainbow magick interior design. With one little brush and a single bucket, we can completely transform a space. But painting a room is only one way to brandish the transformative power of paint.

+ Paint an accent wall

+ Paint an archway over a door or desk to create the illusion of architecture

+ Treat the ceiling trim with a pop of color

+ Add spontaneity with a secret paint job on the inside edge of a door

+ Paint the ceiling with a mural for drama

+ Use stencils to add graphic elements to design

+ Paint the steps of your stairs

+ Add instant romance by painting a design on the ceiling above a light fixture

+ Embellish linoleum tile floors with paint and stencils

+ Paste up wallpaper if you are a glutton for punishment or peel-and-stick wallpaper for instant gratification

+ Apply removable wallpaper and paint over for renter-friendly rainbow magick

PORTALS

Windows, doors, and doorways are thresholds. They are liminal spaces ripe with magickal symbolism. Portals are the paths through which light, people, pets, guests, and everything in our spaces comes into our lives.

Windows

Curtains: Choose colors that support your color story and keep transparency, light filtration, and privacy in mind. No need to be stingy, the more folds the better! Hang your curtains high to draw the eye in a long line from floor to ceiling to create the illusion of space.

Window clings: Removable window clings (or stickers) not only provide privacy or block unattractive views, but quickly infuse a room with colorful light. Window clings are a swift and inexpensive option for bringing color and character to any window.

Stained glass: Hunt for stained-glass windows and suncatchers at flea markets, antique shows, local galleries, or create your own. The technique below is a temporary way to bring the beauty of stained glass into your space.

Temporary stained glass: Mix black acrylic or tempera paint with a squirt of dish soap (washing-up liquid). With a brush, sketch out the black "solder" outlines of your "stained glass" onto the windowpane. Mix your colors of choice with dish soap, just enough to thin them, and fill in your black outlines. When you're ready to change up your windows, mist the paint with water and wipe away with a sponge.

Doors and Doorways

Beaded curtains: Orchestrate a groovy, informal feel by selecting beads in efficacious colors and enjoy their texture and sound.

Edging: Paint a sly mural (or renter-friendly contact paper) and add an unexpected pop of color to the inside of a doorway or passageway to bless everyone who walks through it.

Doorknobs: You touch the doorknob every day. Why not make it a charming touchstone for rainbow magick? Choose a color that speaks to you or revive a dull knob with a lick of paint.

Front door: Paint your front door a vivid color to welcome visitors, pique the interest of passersby, and magickally seal your home. A red door is said to be lucky and welcoming. Blue doors denote friendliness and prosperity. A yellow door communicates high spirits and a sense of humor. Black is protective and wards a home. Purple sends a signal to neighbors that a witch dwells within.

Light bulbs and mats: Splash color outside your home by popping an unusual colored bulb in the porch light. A wisely chosen door mat makes for a warm welcome and provides another opportunity for color magick.

Wreaths: Wreaths are always pleasant and make perfect vehicles for color magick charms. Their round shape is ideal for focusing, receiving, and sending power. This means that wreaths have the possibility to become a portal within a portal.

RAINBOW PORTAL WREATH

Craft your own rainbow magick portal wreath to invite the energies of optimism, strength, vitality, protection, prosperity, and kindness into your space. This sculptural spell acts as a portal for goodwill, drawing wishes into your space while projecting your color magick out into the world.

YOU WILL NEED

- Sturdy paper plate or wreath form
- Scissors
- Recycled cardboard
- Acrylic paint and brushes
- Hot glue
- Wire or string

3. Next, cut your cardboard into strips of varying lengths and widths—the more variation the better!

1. Cut out the center of the paper plate to create a ring.

4. Using hot glue, stick the strips to the paper plate ring or wreath form, working from the outermost edge inward. Keep layering up your painted cardboard strips until your rainbow portal wreath feels full and opulent.

2. Paint the cardboard with colors that evoke energies you want to draw into your home. This may be a monochromatic spell or you may want to incorporate a variety of colors to cover all your magickal bases. Allow the cardboard to dry.

5. Add a twist of wire to the back of your wreath and hang in an auspicious location, such as your front door or over any portal in your space that feels right.

Furniture

Color isn't just for the walls. When creating enchanting interiors, we can reinvent desks, chairs, lamps, coffee tables, and vases with spray paint, chalk paint, or a colorful stain. Large pieces like cabinets, dressers, bookcases, privacy screens, room dividers, and tables command attention and ooze charm when refreshed with a ravishing color.

Découpage is a storied traditional artform with a long mysterious history. Far from being frumpy or dowdy, découpaged furniture has seen the insides of palaces and stately homes for hundreds of years. Beautifully découpaged furniture are works of functional art and have potential to be as whimsical or glamorous as you wish. When découpaging furniture, seek out stylish designed tissue paper or tissue intended for découpage. These extra-large thin sheets are easy to work with and tear cleanly. Much like the redeeming qualities of a good paint job, découpage can quickly save items from landfill. Experiment with reincarnating cast off furniture with paint and collage to conjure your newest rainbow magick statement piece.

Appliances and Hard Surfaces

In rainbow magick, no surface escapes the vision of the Rainbowmancer. Refrigerators, dishwashers, cabinet doors, countertops, and tabletops are perfect for applying contact papers. When working with graphic contact papers, play not only with the magickal correspondences of color but also imagery. Could you enchant your refrigerator with a tropical fruit print to invite abundance? Or goldfish motif to court prosperity? Awaken surfaces with interesting patterns, finishes, and colors that anchor your color story.

Textiles

Textural and dripping with color, textiles allow the Rainbowmancer to paint with soft furnishings. A textile is any printed, woven, or knit fabric. They may be artful, practical, or both! Weave rainbow magick into your interiors with...

- Hanging tapestries (or use fabric)
- Framed textiles
- Cushions
- Blankets and throws
- Slipcovers (sofa covers)
- Quilts
- Sheets and pillowcases
- Upholstered furniture
- Shower curtains
- Tablecloths and table runners
- Upholstered headboards
- Canopies
- Trims and fringe
- Rugs, runners, and mats

Lighting

Illuminate your enchanting interior with the colorful glow of...

* Paper lanterns
* Colored light bulbs
* Dyed lampshades
* Neon signs
* Oil lamps
* Lava lamps
* Light projectors
* Uplighting for art and cabinets
* Rope lights
* Votives
* Taper, pillar, and tea light candles
* String lights
* Crafty chandeliers made from fabric, pom-poms, upcycled jewelry, or papier mâché
* Hanging crystals, disco balls, suncatchers, mirrors, or accessories with a chrome finish to bounce color energies around a room

TIPS FOR COLORED LIGHTS

+ Red lights insinuate drama and passion. These are especially great for night owls and moody entertaining spaces.

+ Orange lights will invigorate a space and promote creativity and energized discussion.

+ Yellow light is warm, welcoming, safe, and complementary to the complexion. Use pools of yellow light around the room for coziness.

+ Green lights promote optimism and connection with the natural world when used deliberately. Too much green light can appear ominous, eerie, or sickly, unless that is your desired effect. (Go bold, you rebel!)

+ Blue lights are cooling and stable. Much like green, blue lights can provide ethereal beauty when used intentionally, but overuse can lead a space into being washed out or morose. Cooling blue lights work well in professional spaces.

+ Violet lighting evokes a fantastical, mystical sensibility and creates an aura of mystery. Violet light can be particularly useful in spaces intended for meditation or spiritual work. Use these lights to promote deep conversations.

+ Pink lights inspire a joyful celebratory atmosphere and tend to make people feel attractive and flirtatious.

+ Mix and mingle colorful lights to create the right rainbow magick blend for your space.

A Note on Rugs

Rugs quite literally lay the foundation of a space. If you are struggling with where to start a color story or tie an enchanted interior together, look to the rug. Rugs can be healing tactile experiences when we lounge on the floor or walk around barefoot, absorbing their color magick throughout the day. They offer a sense of comfort and security. Want a soothing nest for rest and reflection? Choose a rug in calming colors without too much pattern. If you desire a dynamic, decadent vibe, choose a rug with a bold graphic and funky palette.

Rugs can also be used to catch things we don't want from coming into our spaces like dirt, ill will, and psychic sludge. Dark colored rugs near entrances and portals can help trap these unwanted influences.

The Rule of Three

The Rule of Three is less a rule and more a handy trick. To instantly create cohesion in a space, repeat a color three times. For instance, a vase, lamp, and coffee table in the same hue create a visual thread through a parlor. Why three times? Our eyes take pleasure in odd numbers and three is just enough repetition to create a pattern. We may also refer to this rule as "rhythm", one of the key principles of design. Three instances of a color draw our eyes through the space to tie a color story together. Try it and see what happens!

To Look Again

Mitate is a Japanese word meaning "to look again". As an aesthetic concept, *mitate* describes seeing something as resembling something else and using it in a way that differs from the original intended form. While this concept is often used in relation to Zen garden design, *mitate* can also describe a helpful state of mind for the Rainbowmancer. When pulling elements together to create our enchanted interiors, use your Rainbowmancer Sight to look again and see things anew.

What do you already have that wishes to be used as something else? What is already available that could receive new life? How might you use existing elements in an unexpected way? Seeing objects and spaces anew requires us to loosen our grip on notions and shed ingrained ways of observing. This is magick. Revisit your possessions with fresh perspective to discover unexpected potential.

Accessories and Layering Allies

We've treated the walls, selected furniture, illuminated our spaces, chosen textiles and now we can mindfully choose accessories to strengthen our color spell. Accessories are where the magick of layering happens and give an enchanted interior depth and personality. To style your personal space, call upon...

✻ Statement lamps

✻ Artwork you've purchased, produced, or found, and especially kid art!

✻ Books and magazines

✻ Plants and planters

✻ Dishware and glassware

✻ Curated collections

✻ Bunting and garlands

✻ Storage bins and baskets

✻ Candles and candle holders

✻ Sculpture

✻ Faux taxidermy

✻ Curio and personal collections

✻ Tea towels and bath towels

✻ Flowers and fruit (real or faux)

✻ Bowls and vases

✻ Mobiles and mirrors

✻ TV screensaver as art object

✻ Trays

Evolving Environments

Installations and micro retreats are tricks available to the creative Rainbowmancer. These can serve as semipermanent décor, trappings for magickal entertaining, or a mini meditative retreat.

Installations: An installation is a site-specific piece of art. Installations may sprawl to take up entire rooms while others inhabit a cozy corner. Create site-specific rainbow magick in your home with rag or ribbon walls, streamer curtains, or ruffled streamers reaching down from doorways. Use fishing line and sticky tack to create an ethereal garden growing from the ceiling, flower blossoms dangling down to greet you. Maybe glow-in-the-dark mushrooms protrude from the powder room wall. Swathe yourself in color by covering sections of wall with pom-poms, paper fans, or dip-dyed pages of poetry. Project rippling images onto the floors with light projectors. Installations are where interior design, artistry, and rainbow sorcery collide.

Micro retreats: Micro retreats are ideal for Rainbowmancers short on space or privacy. These miniature spaces may be permanent or temporary. Convert a closet into a color temple. Hang a hula hoop tent from the ceiling to instantly create a miniature retreat. Stake out a corner and build a color fort with blankets, pillows, and chairs. Pitch a tent in the yard or attic, then fill it with colorful lights and pillows and appoint it as your color magick sanctuary.

In my personal practice, I've created temporary color forts to host informal dinner parties that gained energy and sprawled into semipermanent installations enjoyed by our friends for months. The enchantment, silliness, and beauty of those unexpected structures brought joy into the lives of everyone who entered. What wishes could you bring forth to invite more play into your living spaces and make the barrier between real and imaginal slightly more porous?

How will you incorporate color magick into your dwellings? What is longing to be made real? How could an enchanted interior support your people and express your genius? Your magick is limited only by your capacity for fantasy. I have no doubts about the robust powers of your imagination, Rainbowmancer.

CAST A RAINBOW GLAMOUR

You are already everything you need to be, Rainbowmancer.
A rainbow glamour assists us in becoming more of
what we already are. How would your life be different
if each day you were decked in bewitchments that
harkened to the truest, most beguiling, wonderous parts
of you? With color, texture, and confidence as your
ever-present entourage? We're about to find out.

MAGICKAL GARMENTS

Magicians are often associated with grand accoutrements like crystal crowned staves, polished onyx seeing stones, and cabinets stuffed with obscure artifacts. However, it can be helpful to note that more mundane and less conspicuous tools are usually the ones that see regular wonder-working action. Everyday tools like clothes. How often do we consider the magickal implications of our wardrobe? What would it be like to roam the world wrapped in a wearable rainbow spell?

What is a Glamour?

Many traditions define a glamour as a temporary spell that makes something appear better in some way. A decrepit shack becomes a castle. A handful of rusty nails become golden coins. A gourd glows up into a gilded horse-drawn carriage. Often these tales belittle the powerful glamours, warning listeners of the sinful perils of superficiality, vanity, and pleasure. However, more recent adaptations have breathed new life into these enchantments, reappropriating the glamour as an accessible, playful, life affirming, and powerful form of personal magickal practice.

A glamour is a conscious creation designed to support our desires and aspirational selves. While a glamour is activated in the spirit of transformation, often this transformation is a festive homecoming and reclamation of ourselves. It feels good when our inner and outer expressions are in harmony. We become aligned and radiant. Let's do more of that.

Constellation of Transformation

Glamour magick writhes with many fascinating tendrils reaching out into fashion, cosmetic arts, language, perfumery, behavior, social skills, and habit creation. Our discussion of rainbow magick glamours will focus on the wardrobe variety. But don't be fooled, glamours are more than outfits, they are artful constellations of transformation, intentional aura emissions expanding beyond the sum of their parts. Glamours create a magickally infused microclimate around the wearer. Your glamour may be created for a particular occasion or worn over a longer period of time as a way to embody your magick daily. The most important question is: Who will you become?

Constructing a Rainbow Glamour

Go to your closet and envision what you see as a selection of magickal tools. Every scrap of fabric, every button, every pocket has potential to contribute to the weaving of your Rainbowmancer's glamour...

A long black trench coat of truth-sensing psychic armor.

A pair of red wool socks to summon grounding forces.

A seafoam green glass pin (brooch) to slowly drip self-love.

A purple paisley scarf to entice an eccentric muse.

As a Rainbowmancer, you are rich in resources for imaginative glamour construction. Whether you choose to wear your glamour out into the world or swan around in the privacy of your home, the rainbow glamour packs a powerful punch on our mood, confidence, and magickal magnetism. Your glamour is a celebratory avatar of your beauty and a jubilant expression of your creative spirit. Let's explore ways you can begin weaving your very own wearable spells.

COLOR PALETTES

When composing a rainbow glamour, you may wish to draw inspiration from a palette. A palette is a family of colors that create visual harmony and tell a specific story. The following are examples of magickally inspired palettes to help kickstart your glamour experimentation.

Seasonal

These palettes draw inspiration and power from the seasons of the year. The color choices reflect the weather, flora, fauna, celebrations, themes, temperature, and symbols expressed through a particular season. Remember, these are not strict prescriptions but offered as a springboard for creative exploration. As seasons and associations vary greatly depending on your location on the planet, it is important to trust your own insights about what seasonality means for you.

Is there a season that speaks directly to the most alive part of you? A season that makes you bloom and gush with creativity? Use the corresponding seasonal palette to explore and deepen this insight. Experiment with using a seasonally inspired glamour to connect with a season more profoundly. If you wish to embody the themes of a particular season, you may wish to consider using your chosen seasonal palette to develop an enchanted capsule wardrobe.

Spring: warm pastel tints. Smacking with freshness, this palette lifts the spirit. Spring themes include rebirth, youthful spirit, wonder, fertility, resilience, play, activation, illumination, cultivation, and growth.

Summer: cool pastel tones. This palette evokes easy breezy softness and effervescence. Summer qualities include beauty, festivity, abundance, passion, *joie de vivre*, creativity, sensuality, sociability, and fruition.

Autumn: warm deep shades. This palette packs richness and depth. Autumnal aspects include generosity, reaping rewards, hominess, refinement, bounty, prosperity, and a hint of the otherworldly.

Winter: cool deep hues. These colors are crisp, striking, and high contrast. Winter shades express introspection, visionary gifts, relaxed authority, maturity, boldness, clarity, prudence, inner strength, cleansing, and balance.

Elemental

These palettes are emblematic of the elements as described in western esoteric traditions. Their power lies in their analogous and sometimes monochromatic simplicity. Employ a classic elemental palette for no fuss magickal focus-pocus.

Earth

Air

Water

Fire

Astrological

Each sign of the zodiac has their very own bouquet of color correspondences. You may wish to use astrological palettes to lean into the bewitching qualities of your sun sign, home in on a planetary placement with glamour as a form of astrological remediation, or explore these collections to playfully attune to an astrological season. If you wish to dive more deeply into astrological glamour magick, locating the placement of Venus in your birth chart can provide rich inspiration for developing your magickal aesthetic.

Aquarius

Aries

Cancer

Capricorn

Gemini

Leo

Libra

Pisces

Sagittarius

Scorpio

Taurus

Virgo

ASSEMBLING YOUR GLAMOUR

To begin our rainbow glamour, we first choose a magickal aim. What do we wish to express with our glamour? What purpose will the glamour serve?

Next, we select color allies to assist us. This may mean homing in on one specific hue (a monochromatic look) or choosing a palette. The magpies among us may find it more appealing to create an ensemble with multiple magickal purposes simultaneously. There is no wrong way to design a rainbow glamour.

Then we gather pieces to create our rainbow glamour. The cunning Rainbowmancer will begin with garments already available—shop your closet! Activate your Rainbowmancer vision, imagine you are seeing each item in your closet for the very first time. Look deeply and consider not only color, but texture, pattern, and structure.

Play with layering to add interest and versatility to your rainbow glamour. Try pairing long items with short items, baggy with fitted, soft with rigid, patterns with solids, natural fibers with synthetic materials, formal with casual. Get curious and fiddle with formal and specialty items that don't often see the light of day. Ask yourself, how would a Rainbowmancer wield this particular item for maximum enchantment?

Accessories

Our *materia magicka* for rainbow glamour also includes a multitude of talismanic accessories.

Jewelry, patches, pins, shoes, bags, belts, gloves, hats, scarves, glasses, tights, shoes, boas, masks, ties, corsages, and anything else you could possibly drape on the body is fair game for rainbow magick.

Feeling queasy about parading around as a magickal Mardi Gras float? Fear not, dear Rainbowmancer. Sometimes the most potent color sorcery is the most subtle. Accessories are the glassy cherry atop a scoop of dreamy vanilla cream. Choosing to channel glamour with an intentional pop of color or a single accessory can be highly effective. This method can be a sophisticated solution if our professional life or personal comfort level with receiving attention don't allow for more gregarious glamours. Punctuate an ensemble with one deliberately selected accessory and allow its magick to permeate your aura.

Body Ritual

The hair, skin, nails and even eyes are a canvas on which rainbow glamour can manifest.

Hair color potions range from temporary spray chalks to permanent dye. Dabble in streaks of temporary hair color or go bold with a full rainbow magick mane. Wigs and hair pieces are a brilliant way to expand the capacity of your rainbow glamour.

Nails can be lacquered in a power color or a variety of hues all at once to emit glamour magick and infuse your daily tasks with rainbow power.

Prescription or costume contacts are a striking form of glamour. Transmit color magick with the winsome periwinkle eyes of a Shakespearean fairy or the penetrating golden gaze of a hawk. You may even wish to charm your contacts or glasses for seeking specific opportunities, seeing the world in a more dynamic way, engaging with the Unseen, or to see through deception.

Make up has unlimited potential as a sorcerous collaborator: lipsticks, glosses, liners, powders, pencils, lashes, and blushes can be used to enhance or create a standalone rainbow glamour. Make up has been cast as sacred, scornful, subversive, and celebratory. How could a witch resist? Brandish make up in ways that gratify your spirit and awaken your inner artist.

Tattoos, temporary tattoos, stickers, and body paint offer another option for wearing color magick on the skin. Body paints and stains allow the Rainbowmancer to carry elements of their glamour in all situations. The following body stain recipe is a simple way to play with the power of body ritual.

Temporary Tattoo Recipe

This temporary tattoo body stain is a perfect way to incorporate color magick as a wearable spell. Use temporary tattoos or body stains to enhance personal ritual, wear sigils, aid healing work, amp up courage, mark rites of passage, offer protection, and simply celebrate the body!

YOU WILL NEED

+ Cornstarch
+ Hot water
+ Food coloring
+ Small bowl for mixing
+ Exfoliator
+ Paintbrush
+ Hand lotion (optional)

1. Combine a small amount of cornstarch with enough hot water to create a paste. If you would prefer your paint to have a smoother texture, add a squeeze of your favorite hand lotion.

2. Next, add some of the food coloring to achieve your desired hue.

3. Mix well until all elements are combined.

4. Cleanse and exfoliate the skin. Use a paintbrush to draw the body stain onto your skin. Allow the mixture to rest on the skin for up to an hour before gently washing with warm water and pat dry. Your tattoo paint may last several days or possibly up to several weeks.

Altered State

The crafty Rainbowmancer can expand their rainbow glamour arsenal by dying, embellishing, painting, or sewing magickal wardrobe elements. Patches, visible mending, embroidery, fabric paint, dye, spray paint, buttons, glass rhinestones, and alterations are all options awaiting the industrious glamour wizard. Sewing is a skill steeped in magick, but don't be intimidated. Practice makes better and there is no satisfaction in the world quite like a garment detailed by your own hand. If stitch witchery is not of interest to you, the hot glue gun, fabric glue, iron on adhesive, and hem tape are all waiting in the wings to make your rainbow glamour dreams come true!

As a longtime student of the rainbow glamour arts, many of my favorite magickal artifacts have been acquired from thrift shops, flea markets, and clothing swaps. Often vintage or retro pieces are of a higher quality with more unique details, tailoring, and textural fabrics. Not only are preloved items an ecologically and economically friendly choice, but they also tend to be more interesting. A great deal of the fun in glamour creation comes from treasure hunting, being inspired by chance, problem solving, creatively repurposing, and experiencing a world rich with resources just waiting for the right mind to uncover them.

The following is a hunting charm straight from my grimoire, designed to aid in scoring perfect preloved resources—glamour supplies or otherwise!

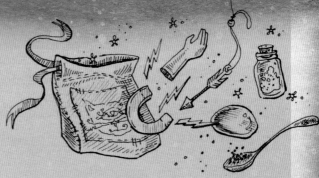

Hunting charm

Use this hunting charm for thrifting success, secondhand discovery, and foraging for perfect resources.

YOU WILL NEED

+ An image of an arrow to "hunt" the perfect item, such as a metal charm, picture, or stone engraved with an arrow

+ An image of a hand to "gather" such as a doll arm, Barbie hand (barbaric, I know), or a picture of an open hand

+ A piece of green aventurine for opportunity

+ A fridge magnet to draw treasures towards you

+ A sprinkle of poppy seeds for luck

+ A pinch of salt to never be without anything one needs for long

+ A fabric bag, handkerchief, fabric scrap, or tin large enough to contain your items but small enough to carry with you

Tuck all the items in the bag. Whisper to the charm bag, giving it detailed instructions on what kinds of treasures you'd like to find. Carry your hunting charm with you any time you are stalking the shops, swaps, or sidewalk for the perfect item. Show gratitude to your charm by occasionally feeding it with a piece of candy or scented oil. Go forth and uncover treasure!

Aureole Headdress

Become a patron saint of glamour and carry your own stunning halo with you wherever you go! This extraordinary crown is easy to make and ideal glamour gear for rituals, festivals, formal outings, or walking the dog. You'll be surprised by how easily it slips into regular rotation in your wardrobe. This is a very wearable spell for bewitching confidence and stupefying glamour.

YOU WILL NEED

+ Headband

+ Cable ties

+ Wire cutters

+ Spray paint in your desired colors

+ Hot glue

+ E600 craft adhesive

+ Faux flowers, pom-poms, tassels, glass crystals, and trim in your desired color

1. Starting from the center, thread the cable ties onto the headband. Work out towards the ends of the headband until it is full of cable ties. Leave about an inch at each end of the headband so it is easy to put on and take off.

2. If you would like to add dimension to your halo, use a wire cutter to snip some of the cable ties to different lengths.

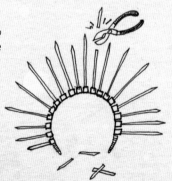

3. Coat the cable-tie-covered headband with spray paint on both sides and allow it to dry.

4. Attach faux flowers, pom-poms, trim, or tassels to the front and back of the base of the crown with hot glue. Attach glass gems or other non-porous accessories with E600 glue and allow the adhesive to cure overnight.

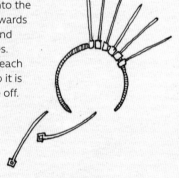

TO CHARGE YOUR HEADDRESS

Energize your headdress with glamorous potency by charging it on your color altar before you plan to wear it. When placing it on your head, visualize the headdress emitting waves of your desired color energy and filling the space around your body with a vitalizing gleam. You are breathtaking.

EXPERIMENT AND DISCOVER

Experiment with both bold and subtle rainbow glamours. A blue feather effortlessly tucked in a hatband and a banana yellow vinyl trench with matching thigh-high boots may vary wildly in visual intensity but not necessarily in power or expression. Try both and see which you prefer. All glamours are good glamours.

Develop and use your glamour over the next several weeks and note the way it changes your behavior, how you feel, your energy level, other people's reactions to your presence, and any synchronicities you experience. You may wish to assemble several different glamours and compare your results. As you play, you will develop an array of glamour options and perhaps joyously stumble upon a second skin—your very own bewitching signature style.

Mere color, unspoiled by meaning, and unallied with definite form, can speak to the soul in a thousand different ways

Oscar Wilde

EXPLORE THE DREAMWORLD

The gauzy expanse of our nighttime dreams is as much a
part of our lives as the hours we're awake. A Rainbowmancer
recognizes the confusing beauty of the dreamscape as a
great library containing spontaneous wisdom and spells
to skillfully alter reality. Close your eyes and drift into
the subtle arts of rainbow magick in the dreamscape.

THE LAND OF DREAMS

Our nighttime visions are a realm of rich inspiration. Dreams communicate in washes of imagery beyond the limitations of language. Their architecture and stories allow us to experience complex and flexible ways of being. Dream wanderings are often ignored or quickly forgotten and evaporate in the light of day. Despite their vaporous nature, dreams are saturated with guidance and signposts that bring texture and new meaning to our waking life. In this quest, we will practice rainbow magick in the dream realms and gather the wisdom of our nighttime phenomena.

The Dream Keeper

Keeping a dream journal in concert with or as part of your color cache can help give our dreams the needed substance to recall messages. Often the goal of a dream journal is to remember the narrative within a dream: the who, what, where, and when of the vision. We can extend our perception into the zones of palettes, color stories, and color guides of our dreams. Even if we are unable to grasp any other filmy details of the dream, the presence of color alone can provide powerful insight. We can use color wisdom to peer deeply into our dreams, learn about ourselves, and stumble upon fresh ideas for casting rainbow magick.

Begin logging your nighttime dreams or any fragments of dream activity you can recall. Focus on the color stories of your dreams. Are the color palettes warm or cool? Are the scenes dark or filled with light? Can you recall any dreams from your past that stand out as memorable? Do any patterns emerge?

Your dream documentation may be a flowing recollection with cinematic detail or just a few key words snatched from the air upon waking. This dream log can be used as a reservoir for inspired actions, healing, and punchy creative ideas.

Dream Allies

There are helpers available to assist in your dream quests. These allies can invite dreams, promote lucid dreams, and support dream recall abilities.

+ Place a special stone and a pinch of herbs in a little bag to create a dream charm and tuck it under your pillow. Helpful stones for dream recall are celestite, howlite, jasper, kyanite, and rhodochrosite. Helpful stones for peaceful sleep are amethyst, rose quartz, and lepidolite. Helpful herbs for falling asleep are anise, bay, lavender, chamomile, violet leaf, poppy, and valerian.

+ Create an essential oil blend or pillow spray to encourage dream recall. Clary sage, rosemary, peppermint, and lavender oils can aid with peaceful sleep and promote lucid dreaming. Mix one part vodka, two parts water and 10 to 20 drops of your essential oil and pour it into a spray bottle. Spritz a little on your body, into your hair, or mist your linens before sleep.

+ Say a little prayer, spell, or rhyme out loud or silently to yourself before sleep asking for help in remembering your nighttime messages.

+ Burning some mugwort on a charcoal disk or as a herbal bundle will unleash powerful dream-aiding magick.

Extraction versus Appreciation

Much has been written about how to correctly interpret and extract use from dreams. Like most phenomena on this planet, we don't need to extract anything from a dream to enjoy it. We can perform dream magick without insisting on cracking the code or dissecting a dream to profit from it. Dreams are made of weird, wonderful primordial jelly. When the predominant culture is one of extraction and relentless pursuit, our dreams can be an oasis of non-striving. It is simply enough to greet dreams, notice them, and be nourished by their presence. The value of dreams can be the dreaming itself. Mystery is a gift.

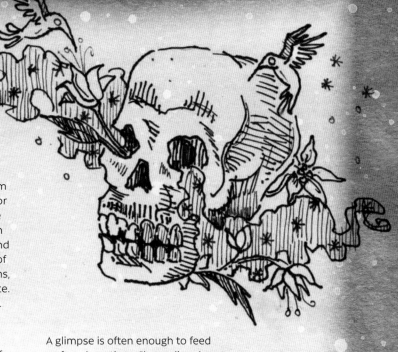

Dreams may not always point to signs in our physical surroundings but often offer mirrors of our subtle emotional bodies. These fleeting visions bridge our inner and outer landscapes, darting in and away from our consciousness like flashing schools of silver fish in the ocean.

A glimpse is often enough to feed us for a long time. Channeling dream imagery, palettes, and stories into art, spells, and reality-bending actions are a generative way to appreciate the spirit of a dream.

Color! What a deep and mysterious language, the language of dreams

Paul Gauguin

Orchestrate the Unordinary

Bend reality by blending the dreaming and waking worlds. Encourage dimensional cross pollination by selecting a detail from a dream to enact in your waking life. How does this work? Perhaps you've dreamed of having a cup of tea with a flock of flamingos in a park reminiscent of a favorite play location from your childhood. To orchestrate the unordinary and bend reality, you would select a detail (or two or three) to perform in your waking life. You might:

✻ Make a cup of tea

✻ Visit the flamingos at the botanical gardens or zoo

✻ Bring a stuffed flamingo on a walk

✻ Wear a t—shirt with a flamingo print

✻ Paint a flamingo in your color cache

✻ Go to the park on a pink—themed scavenger hunt

✻ Take tea in a park near your home

One late winter night, I dreamed of being a Santa Clausian entity, flying over my city throwing fistfuls of paper valentine cards onto people in the streets below. Upon writing down this dream, it felt ripe for reality bending.

Taking to social media, I put out a call, "Seeking help to shower the city with love." Within seconds I was linked to a friend who worked in a home for seniors. Orchestrating the unordinary moved swiftly. Several friends and I feverishly painted, snipped, and sewed late into a February night, making nearly 200 unique handmade valentines, one for each of the residents.

That fragment of dreamtime reverie expanded to envelop a whole community. There was a delirious happiness to our work that crackled with magick that continues to ripple outward. Tug on the single thread of a dream and you tug the threads that connect the universe. Magick is generous like that.

See how it feels to blend the dreaming and waking realms. Practice seeking inspiration in your dreams and test the elasticity of your reality. Be open to insights and coincidences that occur on these otherworldly excursions.

DREAM TRAVEL LATTE

A colorful potion to promote relaxation and soulful nighttime travel. This stunning cold brew caffeine-free latte enchants with blue butterfly pea flower tea and a simple syrup of herbal helpers. Yields two servings of serenity.

TO MAKE THE SIMPLE SYRUP

+ 1 cup (237ml) water

+ 1 cup (192g) sugar

+ 3 to 5 star anise seed pods

+ Handful of fresh mint (or 1 tablespoon of dried mint)

+ 1 teaspoon of dried lavender flowers

Combine the water and sugar in a small saucepan. Heat until the sugar has dissolved. Add the star anise, mint, and lavender. Simmer until the syrup smells delicious. Remove from heat. Strain the syrup into a jar. This tasty complex herbal syrup is delicious with a splash of tonic water or added to hot beverages. Once cooled, store in the refrigerator for up to a month.

TO COLD BREW TEA

+ 2 cups (475ml) filtered water

+ 2 tablespoons of dried butterfly pea flowers

+ Glass jar or pitcher

Pour the water and butterfly pea flowers into the jar. Allow the flowers to cold steep in the refrigerator for 5 to 12 hours. The water will turn bright blue. Strain the flowers and return the tea to the jar. Store in the refrigerator for up to a week.

TO ASSEMBLE THE DREAM TRAVEL LATTE

+ Ice cubes

+ 2 tablespoons simple syrup

+ 1 cup (237ml) butterfly pea flower cold brew

+ ⅓ cup (78ml) milk of your choice

+ 1 teaspoon vanilla extract

Add the ice to your glass and pour the simple syrup over the ice. Pour the butterfly pea flower cold brew over the ice. Mix the vanilla and milk together and gently pour into the glass.

Enjoy luxuriating with your Dream Travel Latte at your color altar, stargazing, or snuggled under the covers before bed.

Dream Voyage Mask

A Rainbowmancer requires proper attire for traversing the dreamscape. Prepare your mind, body, and spirit to drift off quickly and coax technicolor visions with a plush ritual dream mask.

YOU WILL NEED

+ Cotton or satin fabric

+ Fleece or cotton batting

+ Pins or sewing clips

+ 13in (33cm) elastic band (minimum size)

+ Needle and thread

+ Sewing machine or fabric glue

+ Trim, gems, tassels, fringe, sequin appliques, or fabric paint

+ ½ cup (105g) uncooked rice and your favorite essential oil for an extra relaxing weighted mask (optional)

1. Using the pattern template towards the end of this book, cut two mirrored pieces of cotton fabric and one piece of fleece.

2. Put two of the cut shapes together: the fleece shape on the bottom and one piece of cotton with the design facing up.

3. Next, take the elastic band and wrap it across the back of your head to measure from temple to temple. Give the elastic a little stretch when you measure. If the band is too tight your mask will be uncomfortable.

4. Pin the length of elastic to the outside edges of the mask fabric. Then, place the second piece of cotton fabric over the elastic strip, pattern side down. The mask should appear inside out at this point.

5. Pin the fabric along the edge to hold the pieces together, leaving a 2in (5cm) "no sew" gap at the top.

6. Pull the excess elastic band through the gap at the top of the mask. Sew along the outside of the edge of the mask, stopping at the no-sew gap.

7. Snip around the edges of the seam allowance, being careful to avoid the stitches. Turn the mask right-side out. If creating a weighted mask, pour the uncooked rice and add drops of essential oil into the opening in the fabric at this point.

8. With a needle and thread, close the opening with an invisible stitch. You may wish to give your mask a good press with an iron for a crisp finish.

9. Personalize your dream mask with gems, tassels, fringe, rhinestones, appliqué, or fabric paint. Decorate until the mask feels like a mystical vestment ready for dream hopping.

DEVISE A CHROMA ORACLE

While it is true that the wisest part of you knows exactly what to do, it is also true that you may occasionally need assistance in understanding the wisest part of themselves. This is when an oracle can provide a helpful nudge. We can consult the colors of the rainbow to untangle life riddles, receive creative prompts, and stretch our intuitive play by crafting oracular devices.

ORACULAR DEVICES

An oracle is a visionary guide. Divination is the art of finding stuff out. The examples of divination presented in popular culture often place importance on predicting future events, but divination is an excellent method for finding out more about the now. We can use divination practices and oracular tools to come home to ourselves or zoom out and see a much larger picture of the present moment. Oracles tend to get bored by future obsession and gently tease the querent to remind them time is indeed nonlinear.

The rainbow magick practitioner may use a color oracle as part of daily divination practice, inspiration, or communication with the world of color. In this quest, we'll learn how to create, play, and bond with your own personal chroma oracle.

Oracle Possibilities

When creating a color-based divination tool, we have an abundance of forms to choose from. Card decks and runes are tried and true choices, but the Rainbowmancer is not limited to these systems. You may even wish to combine traditional systems with your own oracular inventions to create a unique form of divination.

Consider collecting paint swatches from the store, painted stones, polymer clay cut outs, collaged bottle caps, crystals, buttons, rogue gameboard pieces, play money tokens, laminated magazine cut outs, mini watercolor paintings, marbles, painted bones, driftwood, shells, or a sequence of rainbow sigils stacked as a gif on your phone.

Your oracle may be composed of colorful refuse gathered during your rainbow scavenger hunts and grow organically over time. Scavenger hunts themselves could also be considered a form of open-ended oracular reality reading.

House your treasures in a bag, bowl, or cookie jar. With your eyes closed, ask a question, and draw an item for inspiration. What does it mean to you? What messages does this color carry?

Bonding With Your Oracle

To bond with your oracle, or any enchanted object, it is beneficial to adopt the perspective of the animist. In truth, this is an enriching perspective to adopt towards everything in this world if we can manage it. Animism recognizes things, places, and bodies of all kinds as having beingness. Nothing is dead in the animist realm. Nothing is inert.

Why would we desire to recognize the beingness of objects and non-persons? Firstly, it's polite. Secondly, it allows us to develop relationships with the world. We stop using things and begin working with them. And finally, perhaps the most beautiful reason is that it becomes impossible for the animist to feel lonely.

How can we initiate this friendship with our oracle? Start by giving your oracle an honorable home, a place of importance on your altar, or in a beautiful container. Feed your oracle with light, fresh air, and music. Anoint it with an oil or perfumed smoke. Bring it with you on adventures. Gently wake up your oracle before use by handling it carefully. And most importantly, don't bore your oracle with repetitive leading questions. You already know what to do.

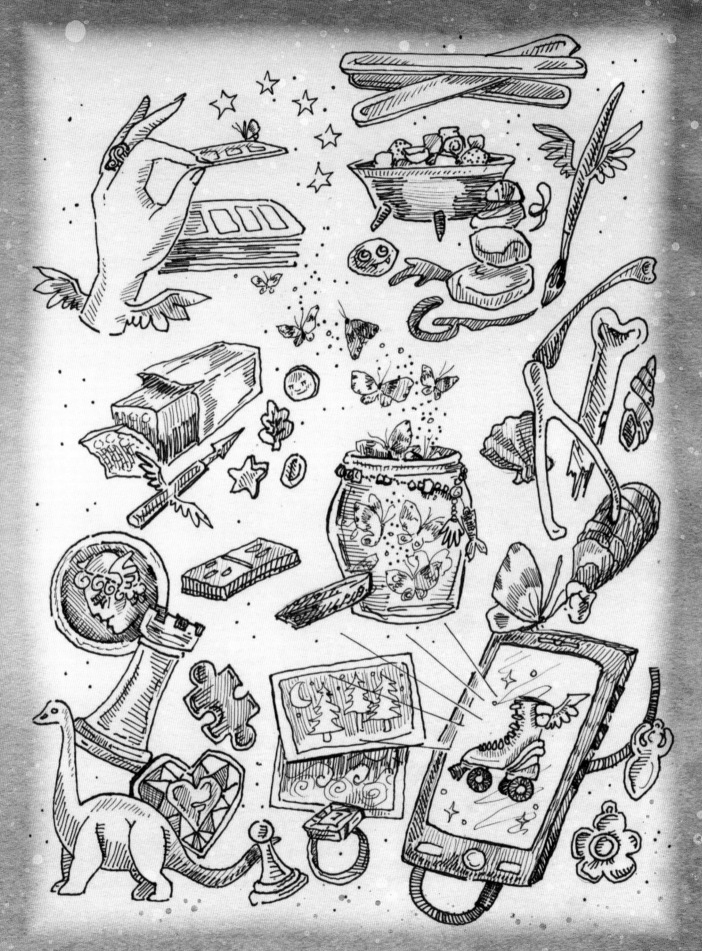

PRISMATIC PENDULUM BELL JAR

Ideal for subtle divinations, a pendulum is a weight suspended from a cord. As the pendulum swings and points, your guidance is made visible.

YOU WILL NEED

+ Necklace chain, cord, key chain, or jewelry links

+ Craft wire or craft cement

+ Crystal shard, seashell, chandelier crystal drop, mini spell bottle, large bead, cocktail ring, or skeleton key to make the pendulum weight

+ Plastic bell jar with base (available online as part of floral arranging or bakery supplies)

+ A drill and small drill bit

+ Eye screw

+ A small cork

+ Pliers

+ Assortment of colored paper

+ Scissors

+ Spray adhesive

1. To create your pendulum, attach your pendulum object of choice to one end of the chain or cord with craft wire or craft cement.

2. At the top of the plastic dome, drill a small hole in the center. The hole should be just large enough to fit the thread of the eye screw.

3. Measure the length of your pendulum to be sure it hangs freely inside the jar and adjust the length if needed. Attach your assembled pendulum to the eyelet of the screw.

4. Next, insert the thread of the screw through the top of the plastic dome (from the inside out) and secure it to the cork.

5. To create the reading surface, cut pie-shaped slices of colored paper to create a colorful wheel. Use as many colors as you desire. Adhere the colored paper to the base of the bell jar with spray adhesive for a flat finish.

6. Place the dome on top of the bell jar base.

TO PERFORM READINGS

Prepare a quiet divination space. Hold the jar in your hands and ask a question. Place the jar on the table and observe which colors the pendulum points to. Using your knowledge of color correspondences, intuit the meaning of this message.

Technicolor Tasseomancy Set

Tasseomancy is the art of interpreting tea leaves, coffee grounds, and wine sediments to reveal a querent's fortune. This technicolor tea set riffs on the ancient art with a rainbow flair.

YOU WILL NEED

+ Large white teacup and saucer, or a small white bowl and saucer (sloping sides will work best)

+ Rubbing alcohol

+ Enamel craft paint

+ Brushes

+ Porcelain paint markers (heat sealing markers made for ceramics and glass)

+ Looseleaf tea or coffee for divination

1. Wipe down the surface of your teacup and saucer with rubbing alcohol to remove any oils or dust.

2. Paint the inside of the teacup with rainbow shapes and swatches in as many colors as you like. Repeat this process on the saucer. Usually, for opaque coverage, enamel paints will require multiple coats. Allow the paint to dry thoroughly overnight.

3. Once the enamel paint layers are dry, add any additional fine detail to your tasseomancy cup and saucer with porcelain paint markers. Follow the manufacturer's instructions for curing before using your tea set.

TO PERFORM READINGS

Brew a cup of looseleaf tea or French press coffee. At your color altar or in a quiet comfortable place, prepare and sip your cuppa until only a spoonful or so of liquid remains in the bottom of the cup.

Holding the cup in your hands, swirl the cup and concentrate on your question or wish. Still holding the question in your mind, place the saucer on top of the cup and flip the cup over. Notice on which colors the leaves or grounds collect on the cup and saucer. Using your color magick knowledge, intuit the meaning of the message based on the hues and shapes chosen by the leaves.

Mysterium Dice Potion

This playful take on dice interpretation combines the power of Rainbowmancy with just enough chaotic energy to keep things interesting. Shake the globe to engage the mystery! Your message emerges from the aqueous rainbow realms.

YOU WILL NEED

+ 1 unfinished wooden die or large wooden geometric polyhedron bead

+ Acrylic paint and brushes

+ Spray clear coat sealant

+ Round glass jar with flat bottom and tight sealing lid

+ Masking tape

+ Spray paint

+ Glass cabochon eye (used for dolls, figurines, and stuffed animals)

+ Beads or glass gems of your choice

+ E600 craft adhesive

+ Water

+ Food coloring

+ Fine glitter or mica powder (optional)

1. Paint the wooden die or polyhedron bead, making each flat surface a different color. Allow the paint to dry completely and seal with spray clear coat. Allow the clear coat to dry for at least 12 hours.

2. Mask off the base of the glass jar with masking tape and spray paint the jar and lid. (Metallic paints look particularly sorcerous.) Allow the paint to dry and carefully remove the masking tape. The clear portion of the glass will become the dice viewing window.

3. Remove the jar lid. Use E600 adhesive to glue any embellishments to the jar lid. Decorate with a glass cabochon eye and glittery glass gems for a spooky effect.

4. Fill the jar with water, a few drops of food coloring, and a pinch of fine glitter, if using, and stir.

5. Add the painted die to the jar. If you use a different dice material to wood, dissolve table salt in the water until your chosen die floats. Then seal the lid.

TO PERFORM READINGS
Hold the jar in your hands and focus on your query. Shake the jar gently and turn the jar upside down to read what the spirits of color have revealed.

BLACK LIGHT HYDROMANCY

Espy messages in surreal streaks of color traveling through water. Supercharge this process-based divination practice with black light for a vivid scrying experience.

YOU WILL NEED

+ A clear jar, vase, or apothecary vessel (the taller the better)
+ Cooking oil
+ Water
+ Neon liquid watercolor paint in various colors
+ Bowl
+ Whisk
+ Black light flashlight

1. Fill your vessel with water until it is three-quarters full.

2. In a small bowl, pour 2 to 4 tablespoons of cooking oil. Drop the neon watercolor paint into the oil. Add 3 to 5 drops of each color you wish to use. Concentrate on your query for this divination session while whisking the oil and watercolor together. Whisk until globules of paint are distributed throughout the oil.

3. When you are ready to perform your hydromancy divination, turn off the main lights and switch on the black light.

4. Gently pour the oil mixture into the glass vessel of water. As the oil settles on the top of the water, watch carefully as colors tumble and fall through the water. What do you see, feel, hear, notice, or remember?

5. Repeat this process for each new question and note your scrying impressions in your color cache.

Ways To Speak with Your Oracle

Consult your oracle...

* For daily inspiration
* Alongside your favorite existing divination tools
* To get creatively unstuck
* When you need to check in with yourself and your feelings
* To converse with disembodied intelligences
* To gamify your adventures in the field
* When fresh perspective is required
* For grimoire, art magick, and creative journal prompts
* To play with dreams
* To play with life
* When you need support
* When you need a riddle to help you grow

ASSEMBLE AN APOTHECARY

What remedies do you wish resided in your wunderkammer of magickal cures? What assortment of charms would be beneficial for you, your loved ones, and community? Now is the perfect time to imagine and create these color-imbued treatments, elixirs, and amulets. Step into the apothecary and peruse a selection of curiosities and restorative spells.

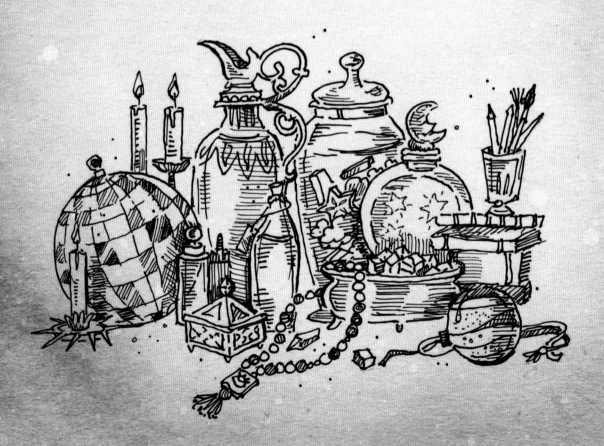

A FLURRY OF CHARMS

From wizardly self-care to meditative aids, doom-slaying confections and ethereal healing elixirs, a Rainbowmancer requires an assortment of stand-by spells to address challenges, grant wishes, and keep the rainbow magick flowing. The following spells are suggestions for stocking your own apothecary.

Elixirs

An elixir is a potion designed to cure. Color magick elixirs can be made directly or indirectly.

Direct Method: Juices, teas, herbs, or edible mix-ins are combined to create a specifically hued drink. For example, if the Rainbowmancer wished to tap into the passionate power of red, they could steep and consume a ruby hibiscus tea as a form of elixir. A direct method elixir puts the color directly into what is to be ingested.

Indirect Method: By contrast, the indirect method for creating elixirs relies on imbuing a liquid with intent by proximity. Indirect methods greatly expand the number of allies and ingredients available for magickal workings. Indirect essences can include the spirit, energy, idea, or poetry of inedible and sometimes intangible ingredients like stones, toys, light, beings, and planets. Indirect methods give us the ability to create elixirs like "essence of disco ball" or "tincture of jade ocelot". Indirect elixirs allow us to incorporate the powers of potentially toxic or indigestible ingredients safely. These far out ingredients are not meant to take physiological effect on the magician, but rather work on a spiritual and imaginal level.

Indirect Elixir Techniques

+ Fill a small glass container with water and place it on top of a colored piece of paper, sigil, or artwork for a predetermined and meaningful period of time.

+ Imbue an elixir indirectly by using a color-specific glass to house a liquid.

+ Set a small glass of water into a larger glass dish or plate. Surround the glass of water with your color *materia magicka* of choice: stones, flowers, herbs, beads, candles, party decorations, or anything else that supports your purpose, and allow the water to be infused for a period of time. You may wish to add a drop of food coloring to strengthen the potency of the elixir.

+ Seal your indirect elixir essence in a dropper bottle. Label it clearly. (There is nothing sadder than a cupboard of unidentifiable mystery essences. Ask me, oh how I know.) Add a few drops of vodka or brandy to preserve and extend the life of your elixirs.

Using Elixirs

Subtly infuse your rainbow magick with additional layers of meaning by adding a few drops of direct and indirect elixirs to foods, teas, baths, skincare, fragrances, or art project media. Take a dram of your elixirs as an energetic supplement to stimulate inspiration.

Rainbow Nectar Soaps

To cleanse away worries and restore a fresh perspective daily.

Rainbow nectar soaps look extra charming stored in a glass apothecary jar beside the bath or offered to guests sink-side in a pedestal dish. Use regularly to maintain excellent imaginal hygiene and playful spirit. Makes approximately 24 miniature soap bars.

YOU WILL NEED

+ ½oz (13g) gelatin or plant-based gelatin
+ 1 cup (237ml) boiling water
+ ¼ cup (85g) honey
+ 1 tablespoon vodka or gin (to prevent mold growth when storing your soaps)
+ 10 to 15 drops essential oil of your choice
+ Beauty grade glitter or edible glitter, cleansing herbs, or color elixirs (optional)
+ ½ cup (170g) body wash or liquid soap of your choice
+ Food coloring
+ Small spray bottle of rubbing alcohol
+ Silicone ice cube, candy, or soap mold

1. In a large bowl, mix the gelatin and hot water, whisking until incorporated.

2. Add the honey, vodka, essential oil, food coloring, body wash, and any additional add-ins. Mix ingredients until well combined.

3. If you are creating multiple hues of soaps, divide the soap mixture into separate containers and add several drops of different food coloring.

4. To prevent bubbles, spray the mold with rubbing alcohol. Pour the mixture into the silicone mold. Refrigerate the soaps overnight.

5. Gently remove the jellies from the mold and store in an airtight container until ready to use.

Soul Soothing Milk Bath

A sultry dreamy bath to restore your essence and boost your glamour emanations.

As a tender form of color sorcery, baths are a gentle compliment to any magickal work. Luxuriate in the aesthetically pleasing opaque water to commune with your color guide and regain your peace.

YOU WILL NEED

+ 2 cups (232g) whole powdered milk
+ 1 cup (116g) Epsom salts
+ ¼ cup (57g) baking soda
+ Powdered soap colorant in the color you desire
+ Glass jar or decanter to store your bath brew powder

Combine all the ingredients in a bowl. Follow the manufacturer's instructions for powdered soap colorant proportions. Store your milk bath brew in a glass jar until you are ready to bathe.

To prepare your bath, add the entire jar to the tub as you draw your bath. Add floating candles, soap rose petals, botanicals, essential oils, or flowers to support your spell.

Aura Crystal Chews

A spell to tease out slumbering wonder, tend the inner child, and banish drudgery.

Crunchy, gummy, and gorgeous, aura crystal chews taste as lovely as they look. Combine colors and flavors to create a wide selection of delicacies to support your vision. Easily cook up a batch of gleaming crystalline confections to share, decorate ensorcelled desserts, give as biodegradable offerings, or nibble at your altar for inspiration.

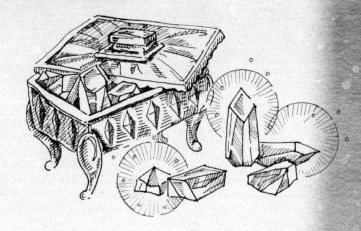

YOU WILL NEED

+ ½ oz (14g) agar agar powder

+ 1¾ cups (414ml) water

+ 3 cups (575g) sugar

+ ½ teaspoon citric acid

+ Candy flavoring (available in craft stores and online)

+ Dram of elixir of your choice

+ Cooking spray or oil

+ Food coloring

+ Toothpick

+ Edible luster dust in gold or silver (optional)

1. In a small saucepan, combine the water and agar agar powder. Allow the powder to bloom for 5 minutes.

2. Turn on the heat and bring the agar agar mixture to a simmer for about 3 minutes, stirring continuously.

3. Sprinkle in the sugar, stirring continuously for another 3 minutes.

4. Remove the saucepan from the heat and add the citric acid, candy flavoring, and elixir.

5. Lightly grease a glass baking dish with cooking spray and pour the candy mixture into the dish.

6. Squeeze a few drops of food coloring onto the surface of the candy mixture and use a toothpick to swirl the colors together for a marbled effect.

7. Transfer the baking dish to the refrigerator for at least 2 hours, until the candy has a gummy bear consistency.

8. Take the dish out of the refrigerator and turn it over, releasing the candy onto a cutting board. With a sharp knife, carefully cut the gummy candy into rectangles and squares of varying sizes. Create crystalline effects by cutting away straight edges at an angle to make flat planes.

9. Allow the crystal candies to set at room temperature on waxed paper for 2 days. A very light crust will form on the outside of the candy, giving it a crunchy outer layer. Finish your aura crystal chews with a flick of edible luster dust for a dazzling golden aura quartz effect.

10. Store the finished crystal chews in an airtight container for up to 2 weeks.

Rainbow Saltscape Witch Ball

A rainbow art object to deflect dubious circumstances and ease the witch in times of uncertainty.

Care for your dwelling with a whimsical take on this traditional protection charm. Historically, witch balls were glass containers hung in the window and filled with wires designed to ensnare nefarious spells cast by evil witches. This rainbow magick adaptation replaces the wire with colorful layers of salt. With potent protective and cleansing properties, salt wards against ill will, promotes harmony, and preserves the peace.

YOU WILL NEED

+ Salt

+ Resealable bags or containers

+ Food coloring or liquid watercolor (as many colors as you wish)

+ A clear round ornament with removeable top

+ Funnel

+ E600 craft glue

+ Gems, stones, twine, talismans to decorate the top

+ Ribbon

1. Pour the salt into a resealable bag and add several drops of food coloring. Too much food coloring will make the salt liquid. Start with just a few drops.

2. Squish the bag until the food coloring is well incorporated. Using separate bags, mix as many colors as you wish to include in your witch ball.

3. With the help of a funnel, spoon a layer of colored salt into the ball. Using different colors of salt, keep spooning in layers until the ball looks like a rainbow layer cake.

4. Replace the cap and seal the ball with E600 glue. Decorate the cap of the witch ball in a way that reinforces your desires for protection, peace, and ease.

5. Thread a ribbon through the top of the witch ball to display.

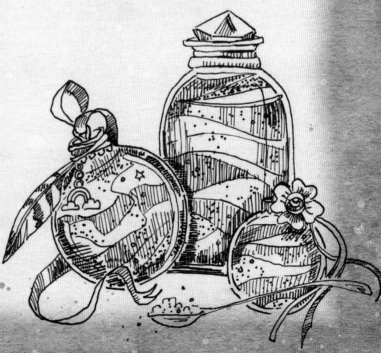

SACRED RUCKUS CONFETTI CANNON

A jubilant spell for new beginnings and for celebratory space clearing.

Make a sacred ruckus, invoke a color guide for celebration, initiate a new beginning, or energetically cleanse a space with a colorful mess. Customize your confetti cannon by filling it with contents pertaining to your magickal purposes.

YOU WILL NEED

+ Paper tube (gift wrap tube, toilet paper, or paper towel core)

+ Scissors

+ Rubber band

+ Tissue paper

+ Glue

+ Confetti (recycled paper confetti in a specific color, dried herbs ground to a powder, offering powder from Scavenger Hunt quest, small flower petals, or dyed rice)

+ Thick decorative paper (such as wrapping paper or recycled paper bag)

+ Ribbon

3. On the end of the tube with the slits, glue a piece of tissue paper over the opening of the tube.

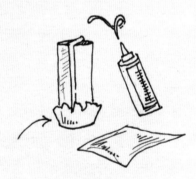

1. Cut the paper tube to be approximately 4in (10cm) long. At one end of the tube cut two 2in (5cm) parallel slits.

4. Temporarily remove the rubber band from the open end of the tube and add a generous teaspoon of confetti.

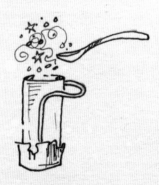

2. Stretch the rubber band through the slits across the tube and then across the top of the tube.

5. Glue a piece of decorative paper over the second opening and replace the rubber band. Trim away any excess tissue paper.

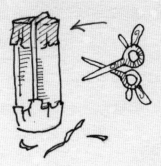

8. You may wish to create a label for your space clearing cannon, which denotes the contents, and decorate your cannon with paper embellishments.

6. Cut a 6in (15cm) piece of ribbon. Thread it through the exposed rubber band to make a tail. This is the pull tab for your cannon. Glue the ends of the ribbon together to secure.

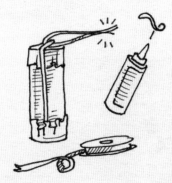

9. To use your sacred ruckus cannon, puncture the layer of tissue paper at the top of the cannon. Holding the cannon straight up, pull the tab and snap to release a puff of spelled confetti!

7. Next, trim a piece of decorative paper to fit and cover the outside of the tube. Secure with glue.

VARIATION
You may also choose to purchase a confetti cannon, decorate the outside, and pour your own spelled rainbow powders inside. Commercially available cannons contain compressed nitrogen which give the explosion more oomph and an exciting audible POOF.

MULTIHUED MUMBLE BEADS

A spell for resilience, mindfulness, and time travel.

Mumble beads grow into prayer beads, meditation aids, self-soothing worry beads, or enchanted statement jewelry. Making these beads is a meditation in itself. The anxious or overwhelmed Rainbowmancer may simply enjoy the focused tactile work of wrapping mumble beads, watching the miniature fiber works accumulate in a soft multihued mountain as time slows and settles around them.

YOU WILL NEED

+ Pipe cleaners

+ Fabric scraps cut into strips

+ Ribbon

+ Hot glue

+ Wooden skewer or knitting needle

+ Needle (to go through layers of fabric)

+ Thread and or embroidery floss

+ Cording

1. Place a tiny dot of hot glue on one end of a pipe cleaner and secure a strip of fabric or ribbon.

2. Wrap the fabric down the length of the pipe cleaner and secure the end with hot glue.

3. Then, wrap the covered pipe cleaner around a wooden skewer into the shape of a bead. You may enjoy plump round beads or elongated tube-like beads. The mumble beads will be lumpy and slightly unpredictable, but this is part of their charm. Secure the free end of the pipe cleaner with a dot of glue.

4. Next, stitch the coil of the bead together with needle and thread. Sew with embroidery floss for a visible decorative stitch.

5. Free the mumble bead from the skewer and marvel at your work. String your mumble beads onto a length of cord to create a powerful tactile meditation tool or rainbow glamour accessory.

VARIATIONS

Add shine and extra interest to your beads by wrapping the covered pipe cleaner with a length of colored wire.

Create jeweled mumble beads by stitching on a few glass seed beads before removing the finished bead from the skewer.

Achieve a fuzzy creature quality by substituting fabric or ribbons for a textural yarn.

TO USE YOUR MUMBLE BEADS

+ Make a single bead with focused intention or prayer and slip it into a pocket for safe keeping and subtle magick, or store it in a special location on your color altar.

+ String your beads onto a cord and use them to count blessings in meditation or before sleep.

+ Create beads in each color of the rainbow. While touching the string of beads invoke the qualities of each color and see them present in yourself.

+ Use a string of mumble beads to make wishes for yourself or others out loud, repeat affirmations, or whisper words of power.

+ Accumulate a stash of mumble beads as spell fodder for crafting rainbow glamour jewelry, trinkets, and baubles.

JOURNEY WITH PRISMATIC MEDITATIONS

There are many yous, Rainbowmancer. One version of you has a body, another lives in the minds of others, another who exists in relationship to nature and culture. There is also a you that flies through your imagination catching falling stars of genius. The imagination is a precious source of personal power for the Rainbowmancer. The following rainbow magick meditations enrich the imaginal dimension of your being for relaxation, fun, and powerful spell work.

VISUAL JOURNEYS

We've awakened our vision and romped with the qualities of the rainbow. We've explored the subtle healing properties of the colors, catalogued correspondences, and dug for treasure in our memories, neighborhoods, and dreams. You have prepared a feast, cast a full-spectrum glamour, and divined wisdom with your own oracular devices. Perhaps you have stumbled into strange and wonderful synchronicities along the way.

Excellent work, Rainbowmancer. You've done well.

In our final pages together, we'll explore guided imagery to strengthen our creative muscles, enhance magickal prowess, and engage with the world in exciting new ways. Grab your cushion and let's journey to the fertile expanse of imaginings.

Melodic Hues

For deep listening and sonic discoveries

While listening to music, tune into the colors appearing in your mind's eye. Frame your deep listening with the question, "If I could see a color right now, what would it be?" If this proves difficult, it's okay to actively imagine it. You may wish to apply this magickal listening experiment while enjoying your favorite songs or when experiencing live music. What color impressions appear to you? What does it feel like to listen with your entire body? You could apply this experiment to voices as well, both singing and speaking. What color is your partner's voice, your cat's meow, your own voice? There are no wrong answers. Only discoveries. Record your findings in your color cache.

The Disco Ball

For instant prismatic energy or rainbow magick ritual preparation

Imagine every cell in your body waking up and taking a long stretch like a cat. Activate your cells by seeing each one as a tiny disco ball. See your skin, hair, toes, teeth, heart, eyes, hands, all teeming with mini sparkling mirrored flecks. Each one throwing rainbows into the space around and within you. All 30 trillion cells twinkling with your favorite colors. Alive. Alert. Buzzing and happy to be part of you.

The Neon Sign

For confidence, tenacity, and perseverance

See your heart as a neon sign, a vibrant crackling beacon that illuminates the night. What does your neon sign say? Maybe it is a shape or sigil? Make it awesome. Make it bold. Make it absolute. Brighten your internal sign by breathing deeply several times. Each breath makes your neon heart beam brighter and bolder. You may wish to add flashing lights around the outline of your neon heart signage. See the neon magick being carried through your whole body, filling the space around your body, until you are full-on electric.

Cephalopod Camouflage

For exploration, resilience, and identity expansion

In your mind's eye, see yourself with the soft numinous skin of a cephalopod, such as a cuttlefish, squid, or octopus. Imagine that like a cephalopod, you have the uncanny ability to pixelate your visage and blend into any surrounding. No pattern is too complex for your mystifying alien biology. You are a master of disguise, a resplendent evolutionary wonder.

Breathing in, imagine your skin flickering and physically changing to adopt the colors and textures around you. What sensations does this activate?

Breathing out, imagine your form returning to its normal state.

Breathing in, disguised. Breathing out, seen.

Once acclimatized to your cephalopodic anatomy, wander to different locations in your imagination: a coral reef, an art museum, or Neptune. See what it feels like to ripple in and out of different environments. Are there any forms that feel particularly charged and powerful for you?

Experiment with lighting up your skin to become a dazzling show of light and color, flickering and pulsating hypnotically. Follow your breathing to keep this effortless trick going. What sensations does this activate for you? When you feel complete with your cephalopod sojourn, return to the home of your own miraculous human body. Note your adventures and impressions in your color cache.

Infinitesimal Travel

For enhancing color spell craft, building structures on the astral, and bonding with magickal objects

To begin this meditation, find an object in the color related to the work you are currently doing: a stone, flower, piece of fruit, ritual jewelry, or Christmas bauble. Hold the object in your hands.

In your mind's eye, see yourself becoming very small. Smaller than that. Small enough that you can slip through atoms and fit inside the object.

What's in like in there?

What does the secret landscape within a lemon look like? What does the pink universe within a seashell reveal at this scale? Does the violet world of an amethyst crystal produce any sound? Does anyone live there? What's the weather like? Walk around and see what and who you find.

Explore these spaces and be sure to record your findings in your color cache.

Rainbow Hands

To calm the mind and fine tune moods

Close your eyes with your hands face up on your lap.

Breathe in deeply and on the outbreath, see your thumbs illuminated by a red glow.

Breathe in deeply and on the outbreath, see your index fingers illuminated by an orange glow.

Breathe in deeply and on the outbreath, see your middle fingers illuminated by a yellow glow.

Breathe in deeply and on the outbreath, see your ring fingers illuminated by a green glow.

Breathe in deeply and on the outbreath, see your little fingers illuminated by a blue glow.

Breathe in deeply and on the outbreath, send a glowing arch of indigo from one palm to the other.

Breathe in deeply and on the outbreath, send a glowing bow of violet from the back of your left hand to the back of your right hand.

Enjoy the calming sensation of your vivid rainbow hands. You may wish to play with this energy like a slinky, allowing the colors to pool in one hand before gently volleying them to the opposite hand.

Stay here with your magick as long as feels good.

Alchemical Heart

For healing, relief, connection, alleviating stress, and robust compassion

The following meditation is informed by the Tibetan Lojong Buddhist tradition as taught by the Buddhist nun, Pema Chodron and adapted for rainbow magick.

Tune in to the feeling that you'd like to change, like loneliness. Feel into the heavy, cold, constricted state of loneliness. How does this feeling appear in your mind's eye? What colors does it conjure?

Imagine breathing these colors deep into your lungs and pouring it into the alchemical container of your heart.

Now consider, what is the opposite of loneliness? What is the antidote to loneliness? Visualize the color antidote in the container of your heart.

On the exhale, send out a wave of this antidote color to anyone in the world who is also feeling isolation or loneliness. Anyone in the past who has ever felt isolation. Anyone in the future who is yet to experience loneliness.

Breathe in the color of difficulty.

Hold the breath.

Transmute it in the alembic of your heart.

Breathe out the relieving antidote color to anyone who may benefit from it.

You may discover the colors have sounds, flavors, temperatures, and textures. As you perform this meditation, you will find burdensome feelings lighten and transform. Practice often. Record your findings in your color cache.

Aurora Borealis

For freedom, cleansing, and restoration

It is night and you are surrounded by the dark silhouettes of massive pine trees. Staring up at the clear sky scattered with milky swirls of stars, you notice a star that seems to wink. It's hailing you with subtle shifts of color. You look at your star intently. You are communicating.

Lost in the concentration of star communication, your feet have left the ground and you are slowly drifting upward into the night sky, and you see it: the aurora borealis.

Waves of angelic light swim impossibly across the sky, washing over and through your body. How does it feel? You sense the intelligence of this phenomenon and decide not to think, but just be with it now with all your senses. Green, Blue, Red. Wave after wave of otherworldly light ribbons pulse through you, the sky, and the landscape below: invigorating, restoring, deeply peaceful, cooling, and filled with wonder.

Then you notice you have actually become the northern lights. Ethereal and vast.

When you feel complete, you make eye contact with your star once more. And feeling a kinship and connection, you are safely lowered to the ground, amidst the trees once again.

Imaginal Archaeology

To stretch the imagination, flex creativity, world build, intuit etheric information, and entertain oneself

This walking meditation can be performed anywhere. Do it when you can safely zone out and mind wander.

Relax your vision and imagine you are viewing the world around you from the center of your forehead, your third eye, your intuitive eye, your Rainbowmancer's eye.

With this eye, you can see new things, a different world is revealed to you. With this eye, you can see auras, the color of the sound a dog makes, the ectoplasm green ghost that lives in the play place of a fast-food restaurant, the shimmering mists emitted by every tree on the street.

This supernatural eye is aware of the energetic architecture of the buildings that used to be here, glowing footprints of animals that used to roam before humans existed, the pulsing threads of fungi below the street, the magenta halo that hovers over the barista.

Use this secret mystical eye at work, on the bus, in the library, in the museum, in the laundromat, at the park, or while pondering a painting. The use of this eye allows stories to unfurl, the imaginal to breathe, and the world of color to burst with life. Places of personal power can be created and inspiration will visit.

Experiment with your Rainbowmancer's eye to stumble upon the impossible every day.

Rainbow Cloud Guided Journey

An extended journey with each hue of the rainbow for deep relaxation and inspiration

If you would like to, you can experience an audio version of this meditation on YouTube.

+ Begin by getting as comfortable as possible sitting or lying down. Drop the shoulders. Feel the space between the shoulders opening as you breath. Gently close your eyes.

+ Bring your awareness to the very top of your head. Relax the scalp, jaw, and muscles around the eyes.

+ Allow your awareness to drift down from your head like a dandelion seed and land softly in your heart space.

+ In the deepest reaches of your heart space, see a pin prick of light begin to flicker. Watch that glowing spark grow.

+ Imagine that from this glowing spot, a rainbow-colored cloud begins to slowly flow. The colorful cloud wafts in a beautiful plume from the center of your chest. It circles around your whole body and covers you like a downy blanket. You sigh audibly, enjoying the refreshing, peaceful presence of this magickal rainbow cloud.

+ Now, with your mind's eye, change the color of the rainbow cloud. Gently will it to transform into a beautiful red hue. A deep juicy energizing red. The color of supple summer roses, fresh berries, and crisp autumn leaves. Feel the red cloud energizing you as it moves over your hair, face, neck, shoulders, chest, arms, back, and legs. Your limbs feel light and heavy all at once.

+ Begin to change the red cloud into a lively spirited orange: the color of long sunsets, sweet tangerines, and shimmering koi. Feel the orange cloud energizing you as it drifts over your hair, face, neck, shoulders. Over your chest, down the arms, down the spine, and through the legs into the bottoms of the feet. Feeling deeply relaxed and glittering from within.

+ Then, the orange cloud is painted a vibrant yellow: the messenger of life-giving sunlight, rolling fields, and delicate songbirds. Feel the yellow swirl around you, invigorating you as it moves over your hair, face, neck, and shoulders. Pouring down the arms, back, and through the legs and each one of the toes. Even more energized. Even more relaxed. Drawing the yellow cloud in through the lungs and the skin.

+ Envision now the yellow cloud blending into a succulent green. The color of emeralds, rain-jeweled lily pads, delicate mossy smells, and the shade of the forest canopy. The soft nutritious energy of the green cloud blankets your entire body, your hair, face, neck, and shoulders. Relaxing your back, running down the arms into the fingertips, through the legs, and softening the feet. Drinking the green cloud into your bones and soul with deep even breaths. Feeling refreshed on every level.

+ On the inhale, see the gorgeous green cloud slowly morphing into blue. Your entire body is buoyed by a dewy blue cloud. The bearer of tropical waters, luminous butterfly wings, vast horizons, and the otherworldly spirit of glaciers. See the blue cloud flowing over each strand of your hair, your eyelashes, cheekbones, and the back of your neck. Down over the chest, into the arms and fingers. Heavy and soothing down the back, legs, and feet. Absorbing the peaceful healing qualities of the blue cloud with the inhale. Feeling aware of your hidden depths, you smile.

+ The cloud expands into a rich indigo. A lavish, enchanting, soul-full indigo cloud pleasantly shrouds your entire body. The prismatic guardian of clouds traveling across the moon, ocean tides, and a peacock's gleaming tail. See this indigo cloud covering your hair, face, neck, and shoulders. Into the chest and traveling down the arms and back. Allowing the serene magick of the indigo cloud to enfold you. Resting deeply in it.

+ The indigo cloud shifts to reveal a calm velvety violet. See and feel the luxurious violet cloud all around you and supporting your body. The color of crystals deep in the earth, summer lightning, and distant misty mountain peaks. Allow the violet cloud to cascade over your whole body,

infused with its restorative powers as it falls over your hair, face, neck, and shoulders. Gracefully pouring over the chest, down the arms, and into each of the fingers. Gently wrapping the back and traveling down the legs. Being bathed in and cared for by this decadent violet cloud. Breathing it deep into your body. Feeling balanced, relaxed, and awake with new awareness.

+ Now in your mind's eye, transform the cloud to contain all the colors of the rainbow. You are lustrous, the quicksilver surface of a bubble, colors lazily drifting and swimming around you. Enjoy this sensation.

+ Call the cloud back into the spark of light deep in your heart: collecting the cloud very slowly. Gently drawing the colors in from the air around you on the inhale. Once you have gathered all the cloud back into your body, slowly bring your awareness from the chest back up into your head...

+ Into the mind. Into the present moment. When you are fully awake in your body, wiggle your fingers and toes. Then slowly open your eyes.

RESOURCES

THE COLOR WHEEL

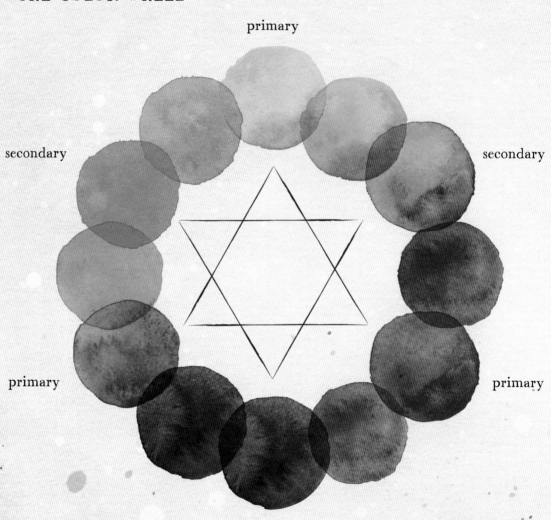

DREAM VOYAGE
MASK TEMPLATE

This mask is full size. A printable version is
available at www.bookmarkedhub.com.

OVER THE RAINBOW

Well done, Rainbowmancer! You have made it over the rainbow. Now, it is your turn to take up the technicolor baton of rainbow magick and make it your own. Play, stretch, practice, flip, and customize these offerings to weave your own bespoke enchantments. We wait with bated breath to see what marvels you bring forth.

May these spells and suggestions fuel you to generate a culture of experimentation and connection.

May you be a flare of joy in the collective imagination.

May you fall ever more in love with a fascinating world inhabited by wonders.

May you refute reduction and abundantly create possibilities for yourself, your magick, and your community.

May you make fun stuff and delight yourself.

May you grow ever more in your magick.

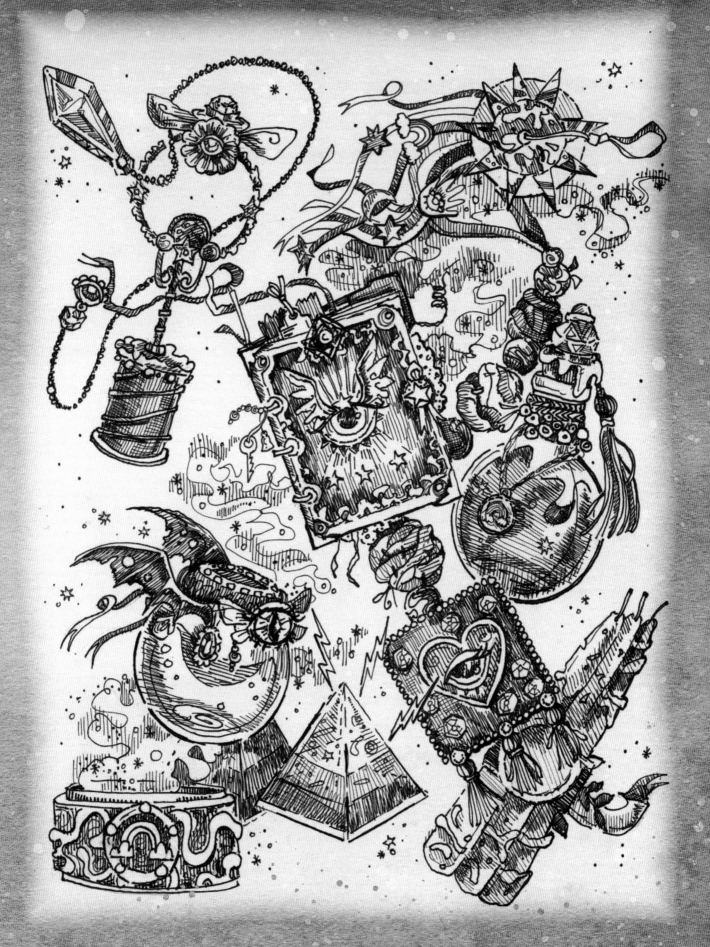

About the Author

Molly Roberts is a mixed media art witch and magick facilitator. She shares her passion for nature and creativity through her workshops, blog, and vibrant YouTube community. Molly lives with her sweetheart and familiars on the shores of Lake Michigan. Molly's first book, *Art Magick*, and the *Art Magick Inspiration Deck* were also published by David and Charles.

To learn more about Molly and her work, visit www.mollyrobertsmagick.com.

Thanks

Thank you to Alex, my favourite, for your companionship and support in every new adventure.

Thank you to my beloved family for your enthusiasm and generosity as I doodled this book.

Thank you for everything, really.

Thank you to the talented team at David and Charles for believing in magick and bringing this rainbow grimoire to life.

Thank you to my editor, Clare, for your humour and essential counsel.

Thank you to every soul who reads these words and makes the world a little more enchanting than it was before.

INDEX

This book has been printed on paper from approved suppliers and made from pulp from sustainable sources.

MIX
Paper from responsible sources
FSC® C012521

Printed in China through Asia Pacific Offset for:
David and Charles, Ltd
Suite A, Tourism House, Pynes Hill, Exeter, EX2 5WS

10 9 8 7 6 5 4 3 2 1

Publishing Director: Ame Verso
Senior Commissioning Editor: Lizzie Kaye
Managing Editor: Jeni Chown
Editor: Jessica Cropper
Project Editor: Clare Ashton
Head of Design: Anna Wade
Designer: Sam Staddon & Jo Langdon
Pre-press Designer: Susan Reansbury
Illustrations: Molly Roberts
Art Direction & Photography: Tom Hargreaves
Production Manager: Beverley Richardson

David and Charles publishes high-quality books on a wide range of subjects. For more information visit www.davidandcharles.com.

Follow us on Instagram by searching for @dandcbooks_wellbeing.

Layout of the digital edition of this book may vary depending on reader hardware and display settings.